BARCELONA

architecture & design

Edited by Sabina Marreiros
Written by Jürgen Forster
Concept by Martin Nicholas Kunz

teNeues

content

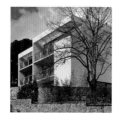
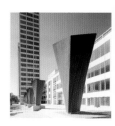

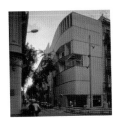 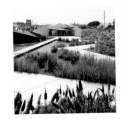

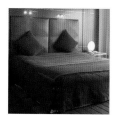
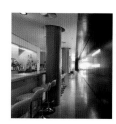

to stay . hotels

to go . eating, drinking, clubbing

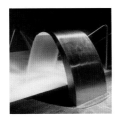

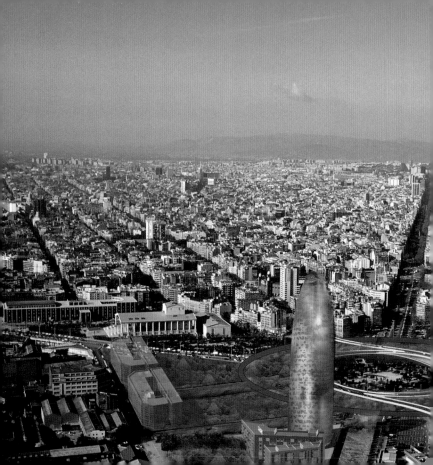

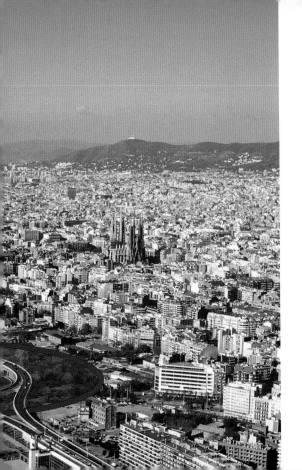

introduction

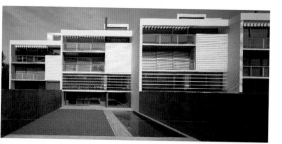

With its lively design and architecture scene, the port metropolis of Barcelona is considered an innovative urban trendsetter. The "Modernisme", a Catalan variety Art Nouveau, and the 1992 Olympic Summer Games have lastingly characterized the modern countenance of the city. Many of the most recently constructed buildings that have emerged from this development provide strong impulses to the contemporary architecture. The volume at hand depicts outstanding examples from current Catalan residential, office, and industrial structures, as well as recently developed theatres, museums and libraries. The current design tendencies are illustrated based on the newest hotels, bars, restaurants, and shops.

Die Hafenmetropole Barcelona gilt aufgrund ihrer lebendigen Design- und Architekturszene als innovative urbane Trendsetterin. Der „Modernisme", eine katalanische Spielart des Jugendstils, sowie die Olympischen Sommerspiele 1992 prägten das moderne Antlitz der Stadt nachhaltig. Viele der jüngst entstandenen Bauten, die aus dieser Entwicklung hervorgehen, geben der zeitgenössischen Architektur starke Impulse. Der vorliegende Band zeigt herausragende Beispiele aus dem aktuellen katalanischen Wohn-, Büro- und Industriebau sowie kürzlich entstandene Theater, Museen und Bibliotheken. Die gegenwärtigen gestalterischen Tendenzen sind anhand der neuesten Hotels, Bars, Restaurants und Shops abgebildet.

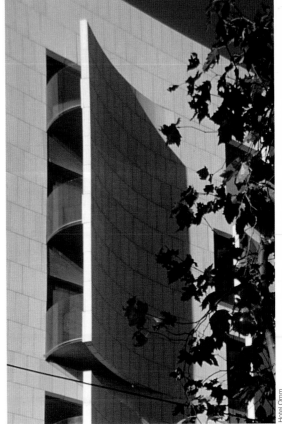

Hotel Omm

9

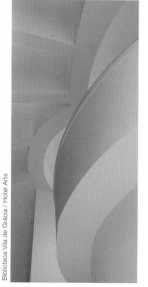

Grâce à sa conception et son architecture pleines de vie, la métropole portuaire Barcelone passe pour une ville innovatrice qui donne le ton en matière urbaine. C'est le « modernisme », une variété catalane du style 1900, ainsi que les jeux olympiques de l'été 1992 qui ont durablement imprégné le caractère moderne de cette ville. De nombreuses constructions récentes issues de cette tendance servent en large mesure d'inspiration à l'architecture contemporaine. Le présent volume montre des exemples hors du commun de la construction actuelle catalane d'habitations, de bureaux et industrielle ainsi que des théâtres, musées et bibliothèques achevés il y a peu de temps. Les tendances actuelles de la conception sont illustrées à l'aide des hôtels, des bars, des restaurants et des magasins les plus récents.

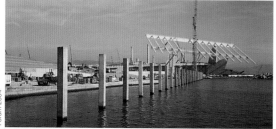

La ciudad portuaria de Barcelona se considera una iniciadora de modas urbanas debido a sus activos e innovadores círculos de diseñadores y arquitectos. El "Modernisme", una variante catalana del estilo modernista, así como los Juegos Olímpicos de Verano de 1992 han marcado de forma duradera la cara moderna de esta ciudad. Muchos de los edificios construidos en el último tiempo en conexión con este desarrollo han dado un fuerte impulso a la arquitectura contemporánea. El presente tomo muestra ejemplos destacables de la arquitectura actual de viviendas, oficinas y edificios industriales en Cataluña, así como teatros, museos y bibliotecas construidos recientemente. Las tendencias actuales en el diseño se hallan representadas en los hoteles, bares, restaurantes y tiendas más nuevas.

to see . living
office & industry
culture & education
public

 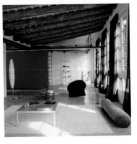

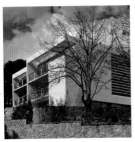 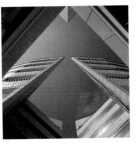 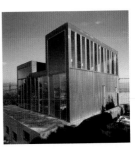

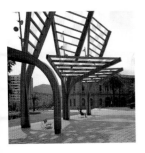 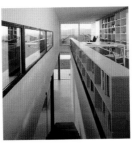 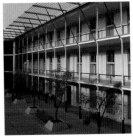

Flex House

Archikubik, Marc Chalamanch,
Miquel Lacasta, Carmen Santana

2001
Carrer d'en Tantarantana, 25
Cuitat Vella

www.archikubik.com

The surfaces of the dwelling are extremely variable. Spatial connections and separations can be created or removed in no time at all. Large portions of the surfaces are not allocated any specific function; the residents adapt the building to their own wants and needs.

Die Flächen des Wohnhauses sind extrem variabel. Räumliche Verbindungen und Trennungen können durch wenige Handgriffe geschaffen und wieder entfernt werden. Einem großen Teil der Flächen sind keine konkreten Funktionen zugewiesen, das Haus wird von den Bewohnern an die eigenen Bedürfnisse angepasst.

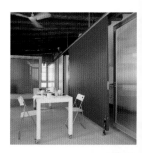

Les surfaces de l'immeuble d'habitation sont extrêmement variables. Les liaisons et les séparations des espaces peuvent être installées et désinstallées par quelques manipulations. Aucune fonction concrète n'a été attribuée à une grande partie des surfaces, l'immeuble étant adapté par les habitants mêmes aux besoins de ceux-ci.

Las superficies de este edificio de viviendas son increíblemente variables. Con unas pocas maniobras se pueden establecer conexiones entre los diferentes espacios interiores y volverse a deshacer rápidamente. Gran parte de las superficies no tienen asignada ninguna función particular, de manera que los habitantes de la casa la pueden adaptar a sus necesidades.

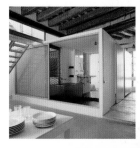

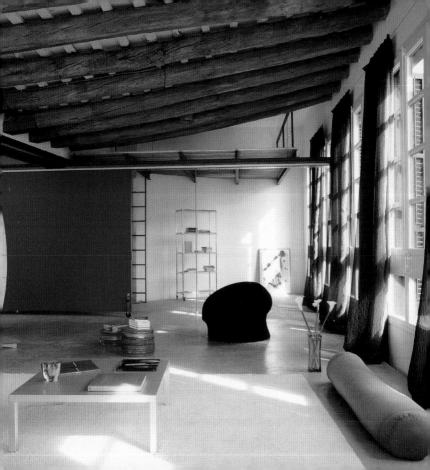

Passeig de Gràcia, 23

Housing Complex

Carlos Ferrater

1999
Passeig de Gràcia, 23 /
Carrer de la Diputació, 259
Eixample

www.ferrater.com

Earlier, the Fémina cinema, which became a victim of a fire, stood on the premises. In order to preserve the streetscape on the famous Passeig de Gràcia the old facade had to be conserved. The residential contemporary building erected behind includes several types of flats that are compatible with the story level of the old facade.

Früher stand auf dem Grundstück das Fémina-Lichtspielhaus, welches einem Feuer zum Opfer fiel. Um das Straßenbild am berühmten Passeig de Gràcia zu bewahren, musste die alte Fassade erhalten werden. Der dahinter errichtete, zeitgemäße Wohnbau beinhaltet mehrere Wohnungstypen, die mit den Stockwerkshöhen der alten Fassade kompatibel sind.

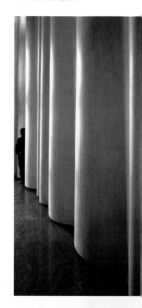

Sur ce terrain se trouvait à l'époque le cinéma Fémina qui a disparu suite à un incendie. En vue de conserver le caractère des rues autour du célèbre Passeig de Gràcia, il convenait de maintenir l'ancienne façade. L'immeuble d'habitation contemporain érigé derrière comprend plusieurs types d'appartements compatibles avec la hauteur de l'ancienne façade.

En este terreno se hallaba antiguamente el cine Fémina, que fue víctima de un incendio. Con objeto de mantener intacta la tradicional imagen del famoso Passeig de Gràcia, hubo de conservarse la antigua fachada. El edificio moderno construido detrás de ella alberga varios tipos de vivienda que son compatibles con la altura de los pisos de la fachada original.

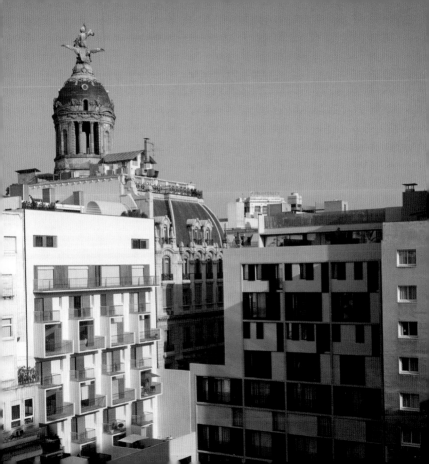

Illa Fleming

Mixed Development

Jaume Bach, Gabriel Mora
Robert Brufau (SE)

1999
Ronda del General Mitre /
Carrer del Doctor Fleming
Sarrià-Sant Gervasi

The housing area consists of one elongated structure and two tower buildings. They are grouped around a semi-public central square under which a cinema extends. Wide balcony galleries emphasize the main facades. Variable wooden louver elements create an irregular, constantly changing pattern.

Die Wohnanlage besteht aus einem langgestreckten Baukörper und zwei Turmhäusern. Sie gruppieren sich um einen halböffentlichen zentralen Platz, unter dem sich ein Kino erstreckt. Breite Balkongalerien betonen die Hauptfassaden. Variable hölzerne Lamellenelemente bilden ein unregelmäßiges, sich ständig veränderndes Muster.

La résidence est composée d'une construction longiligne et de deux tours. Ils se regroupent autour d'une place centrale semi-publique sous laquelle s'étend un cinéma. De larges galeries aux balcons soulignent les façades principales. Des éléments variables en lamelles en bois forment un dessin irrégulier en mouvement constant.

La urbanización consta de un bloque alargado y dos torres, que se agrupan alrededor de una plaza central semipública, debajo de la cual hay un cine. Las anchas galerías de balcones resaltan las fachadas principales. Los elementos lamelares variables de madera forman un diseño irregular que cambia constantemente.

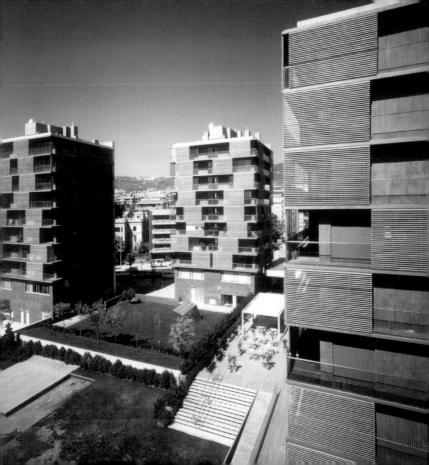

Carrer d'Elisenda de Pinós, 1-5

Four Terraced Houses

Carlos Ferrater

2000
Carrer d'Elisenda de Pinós, 1-5
Sarrià-Sant Gervasi

www.ferrater.com

On the property in the higher section of Barcelona stand four generous single-family homes in rows. Despite their close proximity to each other, they have a high degree of privacy. Large air spaces cut into the bulk of the building break up the structural mass.

Auf dem Grundstück im höhergelegenen Bereich Barcelonas stehen vier großzügige, gereihte Einfamilienhäuser. Trotz ihrer räumlichen Nähe zueinander verfügen sie über ein hohes Maß an Privatsphäre. Große, in das Gebäudevolumen eingeschnittene Lufträume lösen die Baumasse auf.

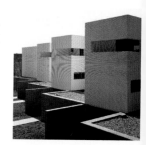

Quatre grands pavillons spacieux et alignés se trouvent sur le terrain dans le quartier sur les hauteurs de Barcelone. Malgré leur grand rapprochement l'un à l'autre, ils offrent une grande intimité. De grands espaces d'air coupés dans le volume de la construction allègent la masse des pavillons.

En el terreno de la zona más alta de Barcelona se han construido cuatro amplias casas familiares en serie. Pese a la proximidad de las viviendas, éstas disponen de un alto grado de privacidad. Grandes espacios vacíos intercalados en la superficie construida disuelven las masas de construcción.

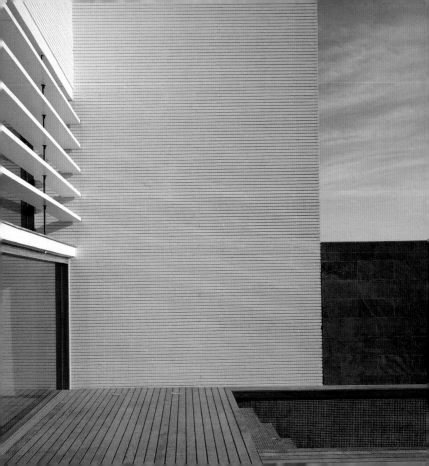

Vora Rondes

MBM Arquitectes

1999
Carrer de Tiana, 12-16
Sant Andreu

www.mbmarquitectes.com

Creating affordably priced living space for young people was the goal of this facility. The glazed access zone is used as a noise buffer against the ring road; all living areas face away from the street. The 49 flats could be constructed for only 330 Euro per square meter.

Preiswerten Wohnraum für junge Menschen zu schaffen war Ziel dieser Anlage. Als Lärmpuffer gegen die Ringstraße dient die verglaste Erschließungszone, alle Wohnräume sind von der Straße abgewandt. Die 49 Wohnungen konnten für nur 330 Euro pro Quadratmeter errichtet werden.

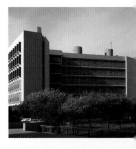

Créer des logements abordables pour les jeunes, voilà le but de cette construction. La zone d'accès toute en verre sert d'insonorisation contre le périphérique, toutes les pièces d'habitation sont orientées à l'opposé de cette rue. Les 49 appartements ont pu être construits à un prix de 330 Euro le mètre carré seulement.

El objetivo de este complejo compuesto es ofrecer viviendas económicas a la gente joven. Como elemento amortiguador del ruido que procede de la avenida de circunvalación se ha previsto una zona de acceso acristalada, y todas las viviendas están situadas en el lado opuesto a la calle. Los 49 pisos se han logrado construir por un precio de tan sólo 330 Euros por metro cuadrado.

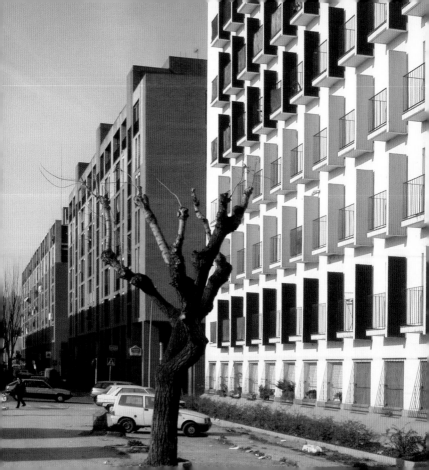

Casa CH
CH House

BAAS, Jordi Badia, Mercé Sangenís
Eduardo Doce (SE)

2001
La Garriga

www.jordibadia.com

The almost completely closed longitudinal facade and widely opened frontal area let the building appear as a matchbox dropped on a lawn. In this manner, it closes itself off from being seen into by the very closely situated neighboring buildings and opens itself up to the garden. A cut-in patio subdivides and lightens the interior.

Durch nahezu vollständig geschlossene Längsfassaden und weit geöffnete Stirnflächen erscheint das Gebäude wie eine im Rasen abgelegte Streichholzschachtel. Es verschließt sich so vor Einblicken durch die sehr nahe gelegene Nachbarbebauung und öffnet sich zum Garten hin. Ein eingeschnittener Patio gliedert und belichtet den Innenraum.

En raison de façades longitudinales pratiquement entièrement fermées et de ses frontons largement ouverts, l'immeuble rappelle une boîte d'allumette posée sur la pelouse. Ainsi, il est fermé aux regards venant par la construction à proximité immédiate et s'ouvre sur le jardin. Un patio sectionné divise et éclaire l'espace intérieur.

Las fachadas longitudinales cerradas casi por completo y las superficies frontales muy abiertas confieren al edificio el aspecto de una caja de cerillas. Así queda oculto a la vista desde los edificios contiguos muy cercanos, abriéndose hacia el jardín. Un patio intercalado estructura e ilumina el espacio interior.

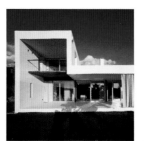
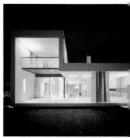

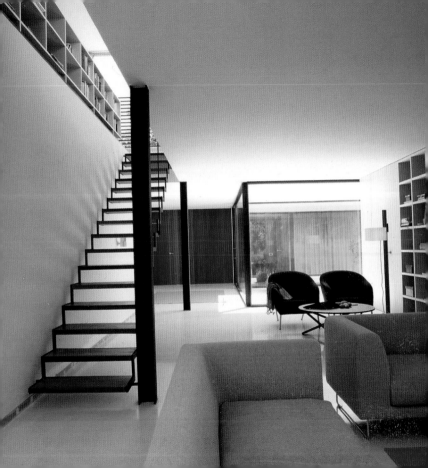

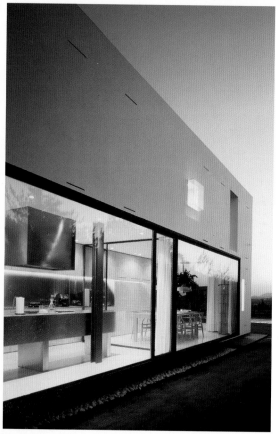

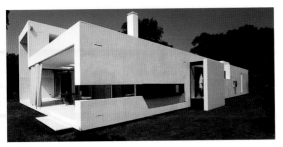

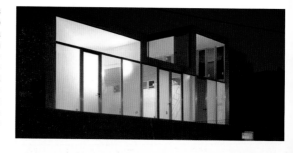

Casa la floresta

La Floresta House

WMA Willy Müller, Fred Guillaud, Caterina Morna
THB Consulting (SE)

2001
Carrer Moret, 18 /
La floresta
Sant Cugat del Vallès

www.willy-muller.com

The bedrooms lie in the solid base of the triangular residential building. High living rooms with free-seating areas in front of them are located above. Parts of the roof area are arranged as terraces. The facades are each allocated their own materiality according to their orientation.

Die Schlafräume liegen in dem soliden Sockel des dreieckigen Wohngebäudes. Darüber befinden sich hohe Wohnräume mit davorliegenden Freisitzflächen. Teile der Dachfläche sind als Terrasse angelegt. Den Fassaden ist, entsprechend ihrer Orientierung, je eine eigene Materialität zugewiesen.

Les chambres à coucher se trouvent dans le socle solide de l'immeuble d'habitation en triangle. À l'étage au-dessus se trouvent les pièces d'habitation aux plafonds élevés avec de grandes surfaces à l'air libre devant. Certaines parties du toit ont été aménagées comme terrasse. En fonction de leur orientation, les façades ont été construites en matériaux différents.

Los dormitorios están ubicados en la sólida base de este edificio de viviendas triangular. Encima de ellos se hallan salones con techos altos, delante de los cuales se han previsto espacios exteriores con asientos. Parte de la superficie del tejado se ha reservado para terrazas. Por su orientación, a cada fachada se le ha asignado un material de construcción propio.

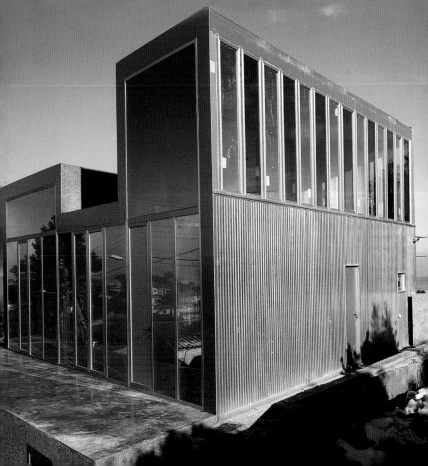

Avinguda Industria, 1-13

Council House

Estudio Joan Pascual Argenté
Gerardo Rodríguez (SE)

2003
Avinguda Industria, 1-13
Sant Just Desvern

This complex is lined up on the Avinguda Industria. Six housing units per level are grouped around the generous central access core of the tower. Two building-deep flats per floor are connected to the four stairwells in the elongated apartment block.

Dieser Komplex reiht sich an der Avinguda Industria auf. Um den großzügigen zentralen Erschließungskern des Turmhauses gruppieren sich sechs Wohneinheiten pro Ebene. In dem langgestreckten Wohnblock schließen an die vier Treppenhäuser je zwei gebäudetiefe Wohnungen pro Geschoss an.

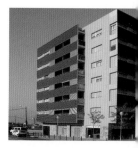

Ce complexe s'aligne sur l'Avinguda Industria. Six unités d'habitation par étage se regroupent autour du noyau central spacieux de la tour. Dans le bloc d'habitation longiligne, deux appartements occupant toute la profondeur par étage sont contigües à quatre cages d'escalier.

Este complejo se encuentra en la hilera de casas de la Avinguda Industria. Alrededor del amplio núcleo central de acceso de la torre, se agrupan seis unidades de viviendas en cada nivel. En cada una de las cuatro escaleras del bloque de viviendas alargado se han adosado por piso dos viviendas que ocupan la superficie entera del edificio.

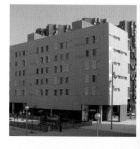

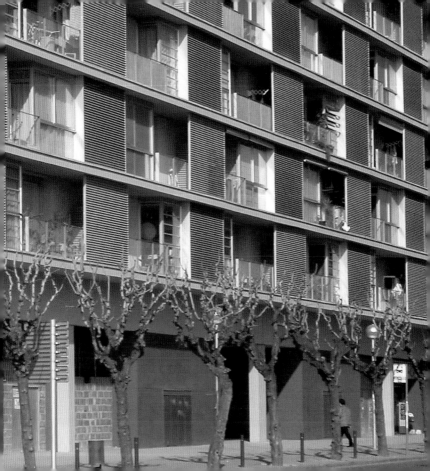

Gas Natural

New Headquarters of Gas Natural

Miralles & Tagliabue Arquitectes Associats
Julio Martinez Calzon, MC-2 Estudio de Ingeniería IOC (SE)

2004
Passeig de Salvat Papasseit
Ciutat Vella

www.mirallestagliabue.com

Based just on its structural mass, the new Gas Natural office building gets in line with the still somewhat sparse Barcelona's skyline. The explicit wish to respect the structural standards of the neighborhood La Barceloneta can still be recognized. This was possible through a clever division of the bulk of the building.

Schon aufgrund seiner Baumasse reiht sich das neue Bürogebäude der Gas Natural in die noch etwas lichte Skyline Barcelonas ein. Dennoch ist der ausdrückliche Wunsch erkennbar, die baulichen Maßstäbe des Viertels La Barceloneta zu respektieren. Dies gelang durch geschicktes Aufteilen des Gebäudevolumens.

C'est de par la masse de sa construction déjà que le nouvel immeuble de bureaux du Gas Natural fait partie de la silhouette un peu clairsemée de Barcelone. On ressent cependant l'objectif bien affirmé de respecter les critères applicables aux constructions du quartier de La Barceloneta. Cet objectif est atteint par une division astucieuse du volume de l'immeuble.

El nuevo edificio de oficinas de Gas Natural destaca ya sólo por su voluminosa estructura en el horizonte algo ralo de Barcelona. Aún así se advierte el propósito de respetar las dimensiones constructivas del barrio de La Barceloneta. Esto se ha conseguido dividiendo elegantemente el volumen del edificio.

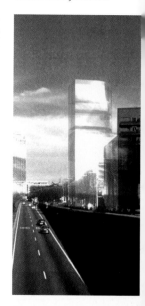

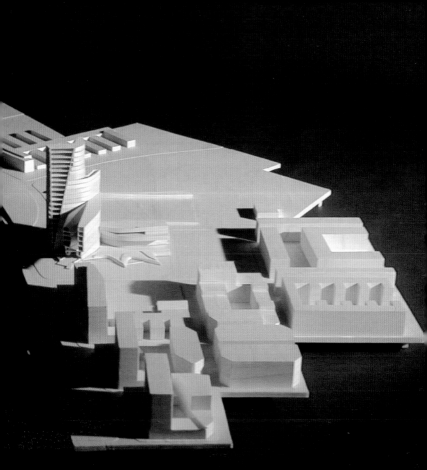

Torre Agbar

Ateliers Jean Nouvel / B720 (Fermin Vazquez)
Brufau/Obiol (SE)

2004 (Building)
2005 (Interior)
Avinguda Diagonal, 209-211
Sant Martí

www.jeannouvel.com

The outer skin of the 142-metre high Torre Agbar is constructed up to the 26th floor as a perforated concrete shell with punched out windows. A domed rooflight made of steel and glass is spanned over that. The architect claims it was inspired by the tower-like cliffs of Montserrat, the jagged Catalan landmark.

Die Außenhaut des 142 Meter hohen Torre Agbar ist bis zum 26. Stockwerk als perforierte Betonschale mit ausgestanzten Fenstern konstruiert. Darüber ist eine Lichtkuppel aus Stahl und Glas gespannt. Als Inspiration für die Gebäudeform gibt der Architekt die turmhaften Felsen des Montserrat, dem schroffen katalanischen Wahrzeichen, an.

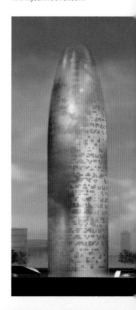

Le mur rideau de la Torre Agbar d'une hauteur de 142 m est constitué par un coffrage en béton perforé aux fenêtres découpées jusqu'au 26e étage. Une coupole de lumière en acier et en verre est tendue pour surmonter le tout. Pour la création de cette forme d'immeuble, l'architecte indique s'être inspiré des rochers du Montserrat, l'emblème escarpé catalan évoquant des tours.

La fachada de la Torre Agbar de 142 metros de altura consta hasta el piso 26 de una cubierta de hormigón perforada con ventanas punzonadas, encima de la cual se despliega una cúpula de luz de acero y cristal. Al diseñar la forma del edificio, el arquitecto se inspiró en los peñascos en forma de torre del Montserrat, el agreste símbolo de Cataluña.

Barcelona Activa
New Headquarter

Roldán + Berengué, arquitectos
José Miguel, Roldán Andrade, Mercè Berengué Iglesias
Manuel Arguijo Vila (SE)

2003
Carrer de la Llacuna /
Gran Via de les Corts Catalanes
Sant Martí

www.roldanberengue.com

The office building lies on the northeastern edge of Cerda's reticular city grid near the intersection of Avinguda Diagonal and Gran Via de les Corts Catalanes, Barcelona's most significant city axis. The ensemble is made up of the old headquarters and the new structure.

Das Bürohaus liegt am nordöstlichen Rand von Cerda's netzartigem Stadtraster, nahe der Kreuzung von Avinguda Diagonal und Gran Via de les Corts Catalanes, Barcelonas bedeutendsten Stadtachsen. Das Ensemble besteht aus dem alten Hauptquartier und den neuen Baukörpern.

L'immeuble de bureaux se trouve à la périphérie nord-est la plus extrême de la trame urbaine en toile d'araignée de Cerda, près du carrefour entre l'Avinguda Diagonal et le Gran Via de les Corts Catalanes, les axes les plus importants de la ville de Barcelone. L'ensemble est constitué par l'ancien quartier général et les nouveaux corps.

El edificio de oficinas está situado en el extremo noreste de la trama urbana reticular de Cerda, cerca del cruce de la Avinguda Diagonal y la Gran Via de les Corts Catalanes, los ejes urbanos más importantes de Barcelona. El conjunto consta del antiguo cuartel general y los nuevos bloques.

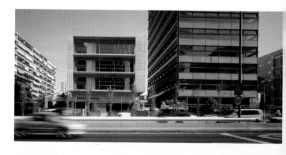

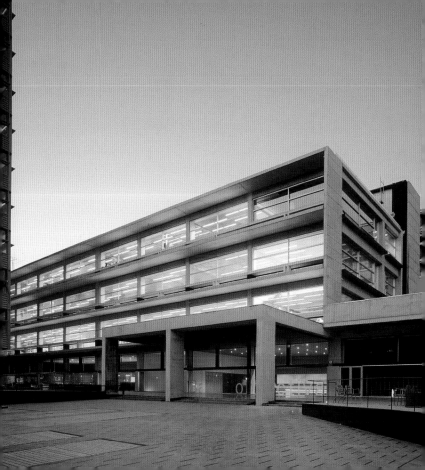

Carrer de Balmes, 145

Apartment and Office Building

Carlos Ferrater

2002
Carrer de Balmes, 145
Eixample

www.ferrater.com

The three story architects' office is situated below the four residential levels. The facade consists of open and closed surfaces on each half. Traditional materials were employed for their four onion-like layers: Stone, steel on the balconies, wood and glass for the doors.

Unter den vier Wohnebenen befindet sich das dreigeschossige Büro des Architekten. Die Fassade besteht jeweils zur Hälfte aus offenen und geschlossenen Flächen. Für ihre vier zwiebelartigen Schichten wurden traditionelle Materialien verwendet: Stein, Stahl an den Balkonen, Holz und Glas für die Türen.

Le bureau sur trois étages de l'architecte se trouve à l'étage en dessous des quatre niveaux d'habitation. La façade est constituée à moitié de surfaces ouvertes et fermées. Des matériaux traditionnels ont été utilisés pour leur quatre couches posées en oignon : la pierre et l'acier sur les balcons, le bois et le verre pour les portes.

Debajo de los cuatro pisos de viviendas se encuentra el estudio del arquitecto, que abarca tres pisos. La fachada consta por partes iguales de superficies abiertas y cerradas. Para la construcción de sus cuatro capas en forma de cebolla se emplearon materiales tradicionales: piedra, acero para los balcones, y madera y cristal para las puertas.

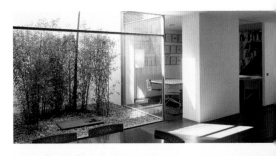

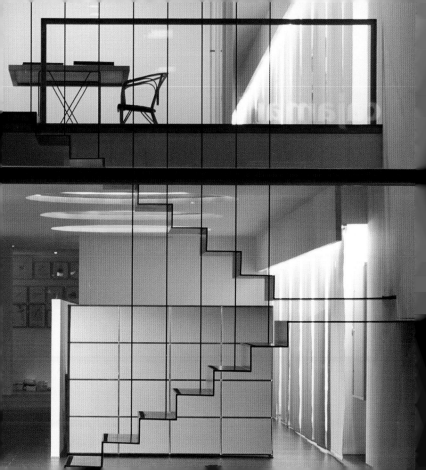

Torre Tarragona

José María Fargas Falp, Federido Fargas Texidó

1998
Carrer de Tarragona, 159-171
Sants-Montjuïc

www.fargas.net

The architect explains the architectural symbolism used in this building as follows: Rationalism demands the utilization of the most reasonable forms. In most cases, these are straight lines, right angles, and flat surfaces. However, if another form is more reasonable, he uses it.

Die bei diesem Gebäude verwendete Formensprache erklärt der Architekt wie folgt: Der Rationalismus verlange die Verwendung der vernünftigsten Formen. Das sei in den meisten Fällen die gerade Linie, der rechte Winkel und die ebene Fläche. Sollte aber eine andere Form rationaler sein, so verwende er diese.

Voilà l'explication fournie par l'architecte sur le langage des formes emprunté pour cet immeuble : La rationalisme exigerait l'utilisation des formes les plus rationnelles. Dans la plupart des cas, ceci serait la ligne droite, l'angle droit et la surface plane. Si, en revanche, une autre forme était plus rationnelle, alors, ce serait elle qu'il emprunterait.

El arquitecto explica el lenguaje de las formas utilizado en este edificio de la siguiente forma: El racionalismo exigía que se emplearan las formas más razonables, que suelen ser la línea recta, el ángulo recto y la superficie plana. Pero si otra forma resulta ser más racional, entonces utilizará esta última.

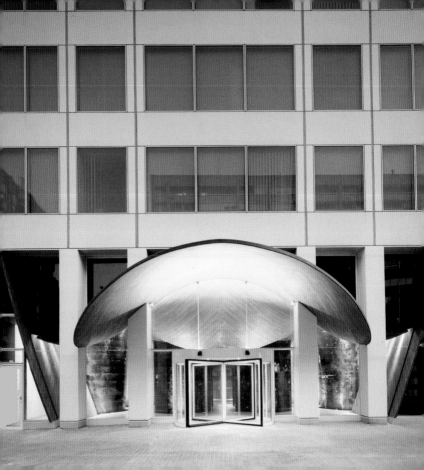

British Summer

Archikubik, Marc Chalamanch,
Miquel Lacasta, Carmen Santana

2002
Carrer de Descartes, 20 bis
Sarrià-Sant Gervasi

www.archikubik.com

The open spaces in the language tour agency extend across two floors. In this company, the high visibility of the colorfully illuminated entrance area replaces the classic advertising panel. The hue changes during the day and in accordance with the seasons.

Die offenen Räume der Vermittlungsagentur für Sprachreisen erstrecken sich über zwei Geschosse. Die Signalwirkung des farbig beleuchteten Eingangsbereiches ersetzt bei diesem Unternehmen die klassische Werbetafel. Der Farbton verändert sich im Laufe des Tages sowie entsprechend der Jahreszeiten.

Les bureaux ouverts de l'agence spécialisée aux voyages linguistiques s'étendent sur deux étages. Pour cette entreprise, l'effet signalétique de cette entrée éclairée en couleurs remplace le tableau classique de publicité. La nuance de la couleur change au cours de la journée ainsi qu'au fil des saisons.

Los espacios abiertos de esta agencia que ofrece viajes de idiomas abarcan dos pisos. El efecto señalizador de la zona de entrada iluminada en color sustituye en esta empresa el clásico cartel publicitario. Su color cambia de tono a lo largo del día y según la estación del año.

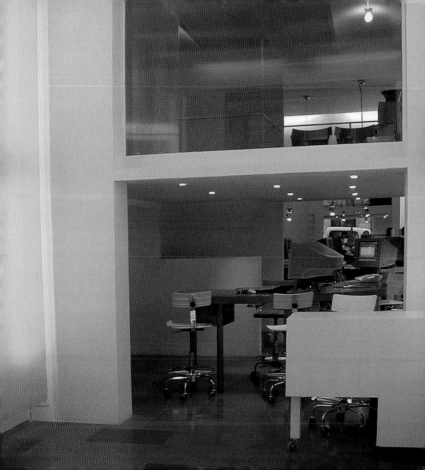

Palacio de Congresos de Catalunya

Catalonia Convention Center

Carlos Ferrater, José María Cartañá

2000
Avinguda Diagonal, 661-671
Les Corts

www.ferrater.com

Two internal streets divide the convention centre into three structures. The largest includes the spacious entrance hall, an auditorium for 2500 people, and the banquet halls. The multifunctional exhibition halls lie next to that. The smallest, winding building accommodates the cafeteria and various services.

Zwei interne Straßen teilen das Kongresszentrum in drei Baukörper. Der größte beinhaltet die geräumige Eingangshalle, ein Auditorium für 2500 Personen und den Bankettsaal. Daneben liegen die multifunktionalen Ausstellungshallen. Das kleinste, geschwungene Gebäude beherbergt die Cafeteria und verschiedene Dienstleistungen.

Deux rues internes divisent le centre de congrès en trois corps. Le plus grand parmi eux héberge le hall d'entrée spacieux, un auditoire pour 2 500 personnes et une salle à banquets. Les halls d'exposition multifonctions sont attenants. Le plus petit bâtiment, en arc, comprend la cafétéria et les différents services.

Dos calles interiores subdividen el centro de congresos en tres bloques. El más grande de ellos dispone de un amplio vestíbulo, además de un auditorio para 2500 personas y una sala de banquetes. Al lado, se hallan las salas de exposición multifuncionales. El edificio más pequeño arqueado alberga la cafetería y diversos servicios.

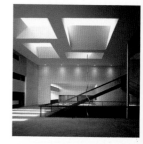

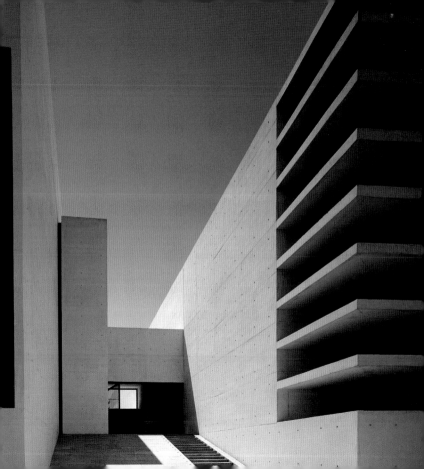

World Trade Center

Pei Cobb Freed & Partners Architects LLP
MC-2 Estudio de Ingeniería IOC (SE)

1999
Moll de Barcelona
Ciutat Vella

www.wtcbarcelona.es
www.pcf-p.com

The World Trade Center is located at the tip of a 500-metre pier in the Barcelona Harbour. The building is subdivided into four arched structures that group around an inner courtyard. In order to be able to meet the complex requirements placed on the development, the building has two access levels.

Das World Trade Center befindet sich an der Spitze eines 500 Meter langen Piers im Hafen von Barcelona. Das Gebäude ist in vier gewölbte Baukörper unterteilt, die sich um einen Innenhof gruppieren. Um den vielschichtigen Anforderungen an die Erschließung gerecht zu werden, verfügt das Gebäude über zwei Zugangsebenen.

Le World Trade Center se trouve à la pointe d'un môle de 500 mètres au port de Barcelone. L'immeuble est divisé en quatre corps en arc qui se regroupent autour d'une cour intérieure. Pour répondre aux différentes exigences quant à son accès, l'immeuble dispose de deux niveaux d'accès.

El World Trade Center está ubicado en la punta de un muelle de 500 metros de longitud en el puerto de Barcelona. El edificio se divide en cuatro bloques abovedados que se agrupan alrededor de un patio. Con objeto de cumplir los más diversos requisitos de urbanización, el edificio se ha provisto de dos niveles de acceso.

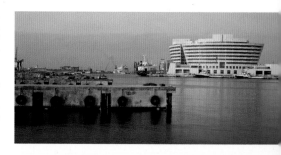

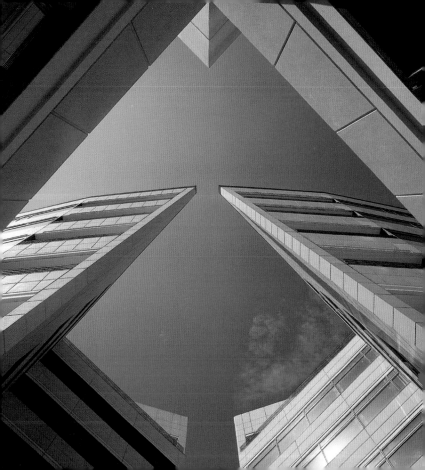

Parc Logistic
de la Zona Franca

Logistic Parc

Ricardo Bofill – Taller de Arquitectura
Eduardo Palao (SE)

2003
Carrer 60, 19
Zona Franca

www.bofill.com

The roof form of the free-port logistics centre office building symbolizes the undulation of the sea. The building heights are staggered from three to five floors in the highest section. The floor plans are meant to ensure the best possible natural lighting of the office areas.

Die Dachform der Bürobauten des Freihafen-Logistikzentrums symbolisiert die Wellenbewegung des Meeres. Die Gebäudehöhen staffeln sich von drei bis zu fünf Geschossen im höchsten Bereich. Die Grundrisse sollen die bestmögliche natürliche Belichtung der Büroflächen gewährleisten.

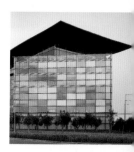

La forme du toit des immeubles de bureaux du centre logistique du port franc symbolise les mouvements des vagues de la mer. Les hauteurs de l'immeuble s'échelonnent entre trois et cinq étages pour la zone la plus élevée. La coupe horizontale est censée assurer un éclairage naturel optimal des surfaces de bureaux.

La forma del tejado de los edificios de oficinas del centro logístico del puerto franco simboliza el movimiento de las olas del mar. Los edificios tienen una silueta escalonada al tener de tres a cinco pisos en la zona más alta. El esquema de distribución de los edificios garantiza la mejor iluminación natural posible de las oficinas.

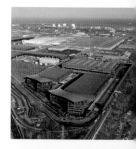

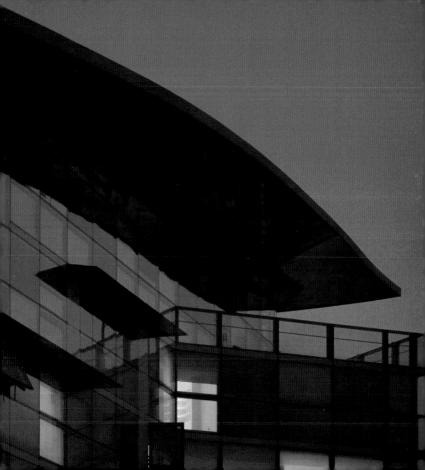

Recycling Plant

WMA Willy Müller, Fred Guillaud
Ingeniería Reventos (SE)

2003
Poligono industrial; Mercabarna
Zona Franca

www.willy-muller.com

The recycling separation plant is divided into both functional and structural areas. Colored graphic elements emphasize the delivery zone. In the area that lies behind this is a conveyor belt that carries the reusable material to the sorting cabins where they are categorized.

Die Wertstoff-Sortieranlage teilt sich sowohl funktional als auch baulich in zwei Bereiche auf. Farbige grafische Elemente betonen die Anlieferzone. Im dahinter liegenden Bereich befindet sich ein Transportband, welches die Wertstoffe in die Sortierkabine befördert, wo sie kategorisiert werden.

L'installation de tri de déchet recyclables est divisée en deu sections différentes par leu fonction et leur construction. De éléments graphiques en cou leurs soulignent la zone d'arr vages de livraisons. L'espace s trouvant derrière comporte u tapis roulant transportant les dé chets recyclables dans la cab ne de tri où ils sont triés en di férentes catégories.

La planta de separación de materiales valiosos está dividida en dos sectores tanto desde el punto de vista funcional como constructivo. Elementos gráficos en color señalizan la zona de entrega. En el área contigua se halla la cinta transportadora que transporta los materiales valiosos hasta la cabina de separación, donde son catalogados.

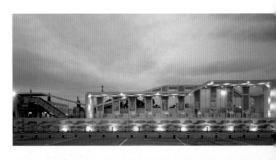

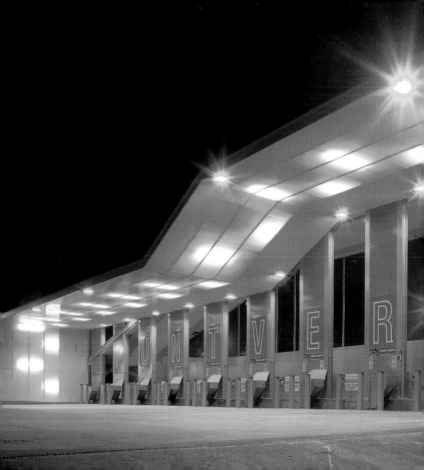

Waste Treatment Plant

Xavier Bonet, Bernard Fernandez, Isabel Pascual
Manuel Arguijo Vila (SE)

2000
Carretera de Vilafranca a Sitges
Vilafranca del Penedès

To improve the functionality of the recycling plant, several areas were integrated through two new structures. They allow for natural lighting and ventilation and protect the plant components from rain. Slanted front faces ease access and let the volume appear to be light and dynamic.

Um die Funktionalität der Verwertungsanlage zu verbessern, wurden mehrere Bereiche durch zwei neue Baukörper zusammengefasst. Sie erlauben natürliche Belichtung und Belüftung und schützen die Anlagenteile vor Regen. Geneigte Stirnseiten erleichtern den Zugang und lassen die Volumen leicht und dynamisch erscheinen.

En vue d'améliorer la fonctionnalité de l'installation de traitement, plusieurs sections ont été regroupées par deux nouveaux corps. Ceux-ci permettent un éclairage et une aération naturels et protègent les éléments de l'installation de la pluie. Les frontons inclinés facilitent l'accès et confèrent aux volumes du dynamisme et de la légèreté.

Para mejorar la funcionalidad de la planta de tratamiento de residuos, se unieron varios sectores mediante la construcción de dos nuevos bloques. Estos permiten una iluminación y ventilación naturales y protegen las diferentes partes de la instalación de la lluvia. Los frentes inclinados facilitan el acceso y confieren un aspecto ligero y dinámico a las voluminosas estructuras.

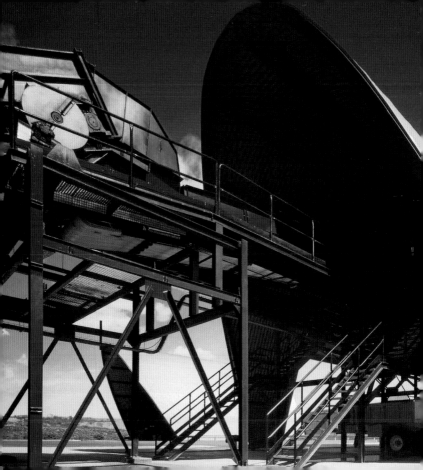

Carrer de la Selva, 4
Office Building

Estudio Joan Pascual Argenté
Gerardo Rodríguez (SE)

2002
Carrer de la Selva, 4 /
Polígono Mas Blau
El Prat de Llobregat

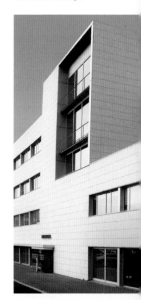

A main foyer extending through all floors subdivides the building internally and externally. As side rooms are also allocated to this area, the office space remains completely flexible. Both uppermost floors are recessed by one grid each.

Eine zentrale Eingangshalle, die sich über alle Geschosse erstreckt, gliedert das Gebäude intern wie extern. Da in diesem Bereich auch die Nebenräume angeordnet sind, bleiben die Büroflächen voll flexibel. Die beiden obersten Geschosse sind um jeweils ein Rasterfeld zurückversetzt.

Un hall d'entrée central s'étendant sur tous les étages divise l'immeuble en interne comme en externe. Étant donné que cet espace comporte également les locaux attenants, les surfaces de bureaux restent totalement flexibles. Les deux derniers étages sont chacun en retrait d'une longueur de panneau.

Un vestíbulo central que se extiende por todos los pisos subdivide tanto el espacio interior como exterior del edificio. Dado que en esta zona también se hallan las habitaciones accesorias, las superficies con oficinas permanecen totalmente flexibles. Los dos últimos pisos están desplazados hacia atrás un cuadrado de la retícula, respectivamente.

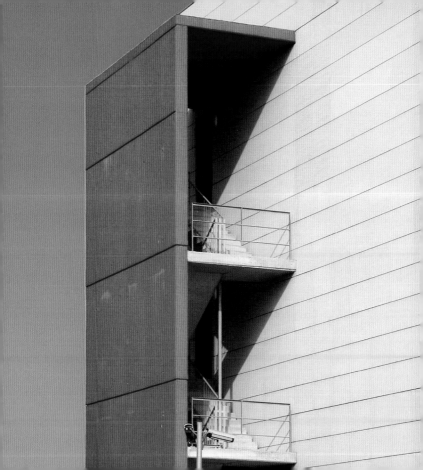

Textile Factory

WMA Willy Müller
Indus SA (SE)

1999
Carrer de Sant Adrià, 68
Sant Andreu

www.willy-muller.com

By installing a second level, the renovated factory building has become useful as a connected production and storage area. The suspended containers for office, workshop, and exhibition are connected with each other via catwalks. On account of the level difference, the new rooms can be accessed directly from the street.

Durch den Einbau einer zweiten Ebene wird die renovierte Fabrikhalle als zusammenhängende Produktions- und Lagerfläche nutzbar. Die aufgehängten Container für Büro, Werkstatt und Ausstellung sind über Stege miteinander verbunden. Die neuen Räume können aufgrund des Niveauunterschiedes direkt von der Straße erschlossen werden.

L'intégration d'un deuxième niveau permet l'utilisation du hall d'usine rénové en tant que surface en continu de production et de stockage. Les containers suspendus pour le bureau, l'atelier et l'exposition sont reliés par des traverses. Grâce aux différences de niveaux, les nouveaux locaux sont directement accessibles par la rue.

Gracias a la construcción de un segundo piso, la nave renovada de la fábrica puede utilizarse ahora como superficie continua de producción y almacenamiento. Los contenedores colgantes que albergan las oficinas, el taller y la exposición están unidas entre ellas mediante pasarelas. A las nuevas dependencias se puede acceder desde la calle gracias a la diferencia de nivel.

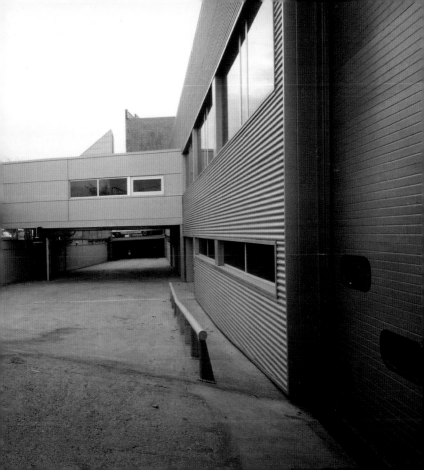

Arruga Studio

Carlos Ferrater

1997
Espigolera, 19-21 /
Polígono industrial 1
Sant Just Desvern

www.ferrater.com

The project arose from the idea to relocate the Arruga film studio to an industrial area on the periphery of Barcelona in order to shoot industrial films there. The extensively glazed principle facade metamorphoses nights into a kind of cinema screen, in a showcase, which reveals the function of the buildings: the production of films.

Das Projekt entstand aus der Idee, das Arruga Filmstudio in ein Industriegebiet an der Peripherie von Barcelona zu verlegen, um dort Filme „industriell" zu fertigen. Die großflächig verglaste Hauptfassade verwandelt sich nachts in eine Art Kinoleinwand, in einen Schaukasten, der die Funktion des Gebäudes enthüllt: die Produktion von Filmen.

Le projet est issu de l'idée de transférer les studios Arruga dans un quartier industriel à la périphérie de Barcelone pour fabriquer des films « d'une manière industrielle ». La nuit, la façade principale spacieuse se transforme en une sorte de grand écran, en une vitrine, dévoilant la fonction du bâtiment : la production de films.

El proyecto surgió de la idea de trasladar el estudio cinematográfico Arruga a un polígono industrial en la periferia de Barcelona, para producir en él películas de forma "industrial". La fachada principal ampliamente acristalada se transforma de noche en una especie de pantalla de cine, en una vitrina que descubre la función del edificio: la producción de películas de cine.

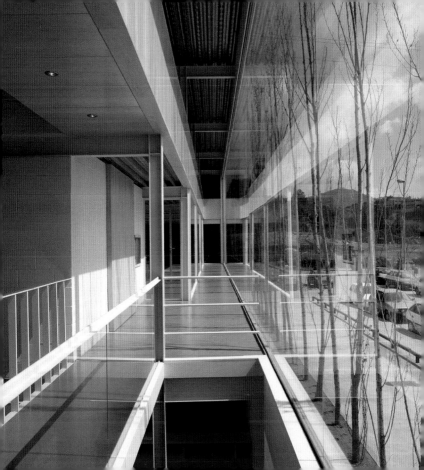

Museu d'Art Contemporani de Barcelona

Museum of Contemporary Art Barcelona

Richard Meier & Partners, Architects, Thomas Phifer,
Obiol, Robert Brufau, Moya y asociados (SE)

1995
Plaça dels Àngels, 1
Ciutat Vella

www.macba.es
www.richardmeier.com

The new museum for contemporary art presents itself as an autonomous, sculptured object that clearly stands out from the homogenous structure of the surroundings. Its three-story cylindrical reception hall subdivides the cubic building. The ramps in front of the main facade make the exhibition floor accessible.

Das neue Museum für zeitgenössische Kunst präsentiert sich als autonomes, skulpturales Objekt, das sich deutlich von dem homogenen Gefüge der Umgebung abhebt. Seine dreigeschossige, zylindrische Empfangshalle gliedert den kubischen Bau. Die Rampen vor der Hauptfassade erschließen die Ausstellungsgeschosse.

Le nouveau musée d'art con temporain se présente comm un objet autonome et sculpté qu se distingue nettement de l structure homogène des env rons. Son hall de réception cy lindrique sur trois étages struc ture la construction en cube. Le rampes devant la façade princ pale permettent l'accès aux éta ges d'exposition.

El nuevo museo de arte contemporáneo se presenta como una obra escultórica autónoma, diferenciándose claramente del complejo homogéneo circundante. Su vestíbulo cilíndrico de tres pisos subdivide el edificio cúbico. A través de las rampas frente a la fachada principal se pasa a los pisos que contienen las exposiciones.

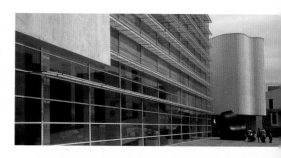

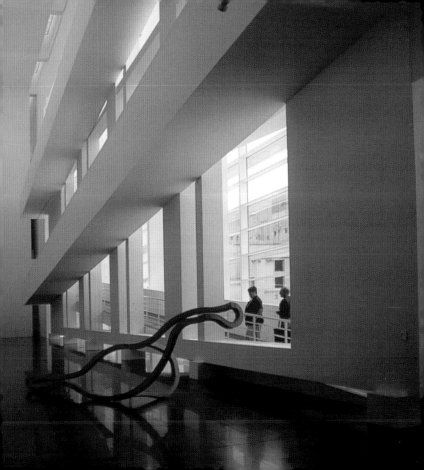

Museu Picasso

Picasso Museum, extension

Jordi Garcés
JG&Instalaciones (Ramon Cos)
Rafael Soto (SE)

2003
Carrer de Montcada, 15-23
Ciutat Vella

www.museupicasso.bcn.es
www.jordigarces.com

Since the most recent extension, the museum complex now consists of five neighboring, medieval residential buildings. The buildings are accessible via a central lane, which also connects the old yards with each other. The museum was given a few new facades toward the garden and the adjacent public square.

Der Museumskomplex besteht nach der jüngsten Erweiterung nun aus fünf benachbarten, mittelalterlichen Wohnhäusern. Die Gebäude sind über eine zentrale Gasse erschlossen, welche auch die alten Höfe miteinander verbindet. Zum Garten und dem angrenzenden öffentlichen Platz hin hat das Museum einige neue Fassaden erhalten.

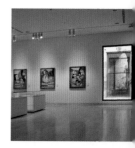

Suite à sa récente extension, le complexe de musées est désormais composé de cinq immeubles d'habitation avoisinants datant du moyen âge. Les immeubles sont accessibles via une ruelle centrale qui relie également les vieilles cours. Du côté jardin et vers la place publique attenante, le musée a été doté de quelques nouvelles façades.

Tras su última ampliación, el complejo del museo consta de cinco edificios de viviendas medievales adyacentes. A los edificios se accede por una callejuela central que conecta además los patios antiguos. Hacia la parte del jardín y de la plaza pública, el museo ha obtenido nuevas fachadas.

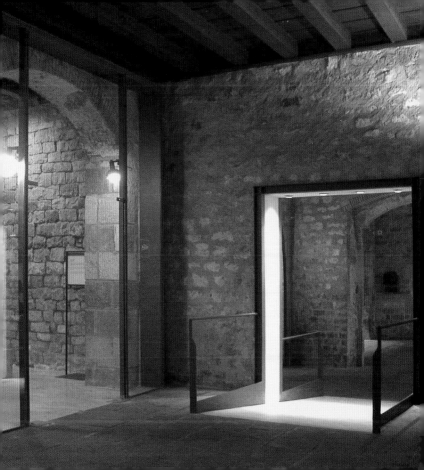

Instituto del Teatro

New Headquarters of the Teatre Institute

Artigues & Sanabria
Robert Brufau (SE)

2000
Plaça de Margarida Xirgu
Sants-Montjuïc

The institute is divided into two functional areas: an internal instruction area used by the various drama and dance schools and a theatre area with two theatres that enable public performances. The new theatre-institute structures are assembled around an atrium that serves as the entrance hall.

Das Institut ist in zwei Funktionsbereiche unterteilt: Einen internen Lehrbereich, den verschiedene Schauspiel- und Tanzhochschulen nutzen und einen Spielbereich mit zwei Theatern, die öffentliche Aufführungen ermöglichen. Die Baukörper des neuen Theaterinstituts gruppieren sich um ein Atrium, das als Eingangshalle dient.

L'institut est divisé en deux espaces fonctionnels : Un espace interne d'enseignements utilisé par plusieurs hautes écoles de théâtre et de danse, et un espace comprenant deux théâtres permettant des représentations publiques. Les corps du nouvel institut de théâtre se regroupent autour d'un atrium qui sert de hall d'entrée.

El Instituto está dividido en dos áreas funcionales: Una zona de estudio interna, utilizada por las diferentes escuelas de baile y de arte dramático, y una zona para actuaciones con dos teatros, en la que se pueden celebrar representaciones públicas. Los complejos del nuevo Instituto del Teatro se agrupan alrededor de un atrio que sirve como vestíbulo.

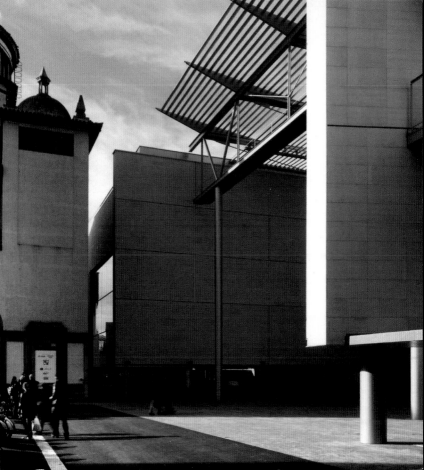

Biblioteca Universitaria de la U.P.F.

University Library

Lluís Clotet Ballús, Ignacio Paricio Ansuátegui
NB-35 (Jesús Jiménez) (SE)

1999
Carrer de Wellington, 50
Sant Martí

www.upf.es

After extensive reconstruction, the university library reading room is now located in the Ciutadella park's old water reservoir. In order to retain the monumental character of the space all other areas in the library are accommodated in an accompanying building.

Nach umfangreicher Sanierung befindet sich in dem alten Wasserdepot des Ciutadella-Parks nun der Lesesaal der Universitätsbibliothek. Um den monumentalen Charakter des Raumes zu erhalten, sind alle weiteren Bereiche der Bibliothek in einem Begleitgebäude untergebracht.

Après un assainissement approfondi, l'ancien dépôt d'eau du parc Ciutadella héberge désormais la salle de lecture de la bibliothèque universitaire. Pour conserver le caractère monumental de la pièce, toutes les autres sections de la bibliothèque ont été installées dans un immeuble d'accompagnement.

Después de su amplia restauración, el antiguo depósito de agua del parque de la Ciutadella se ha transformado en la sala de lectura de la biblioteca universitaria. Para conservar el carácter monumental del recinto, todas las demás secciones de la biblioteca se han trasladado al edificio anexo.

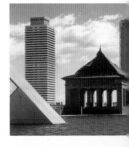

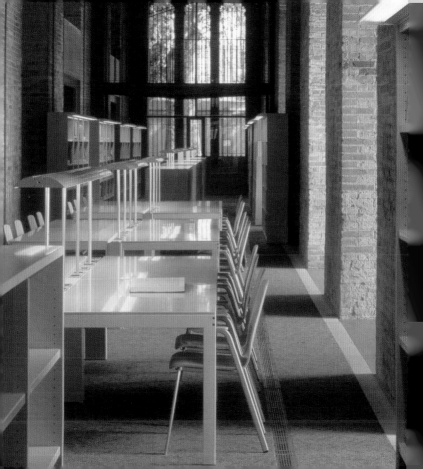

Universitat Pompeu Fabra

Pompeu Fabra University

MBM Arquitectes
Margarit i Buixadé (SE)

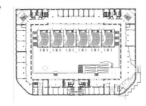

2000
Carrer de Ramon Trias Fargas, 27
Sant Martí

www.upf.es
www.mbmarquitectes.com

Two new structures have been adapted to the newly covered inner barracks yard from the 19th century, which has been lowered. The lecture hall building is completely glassed in; the studies for employees are wrapped in a wooden facade. The access areas, studios, and side rooms are located in the renovated old building.

In den neu überdachten und abgesenkten Innenhof der Kaserne aus dem 19. Jahrhundert sind zwei neue Baukörper eingestellt. Das Hörsaalgebäude ist vollflächig verglast, die Studierzimmer für Mitarbeiter hüllen sich in eine hölzerne Fassade. Die Erschließungsflächen, Studios und Nebenräume befinden sich im renovierten Altbau.

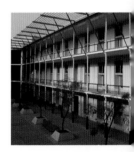

Deux corps ont été construits dans la nouvelle cour intérieure au toit nouveau et abaissée de la caserne du 19e siècle. L'immeuble hébergeant l'amphithéâtre est construit entièrement en verre, les cabinets de travail des employés s'habillent d'une façade en bois. Les zones d'accès, les studios et pièces attenantes se trouvent dans la construction d'avant-guerre rénovée.

En el patio interior del cuartel del siglo XIX, cuya altura se ha reducido y que luce un nuevo tejado, se han instalado dos nuevos bloques. El edificio de las aulas se ha acristalado completamente, mientras que las salas de estudio para los colaboradores tienen una fachada de madera. Las zonas de acceso, los estudios y las habitaciones accesorias se encuentran en el edificio antiguo renovado.

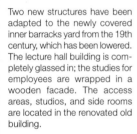

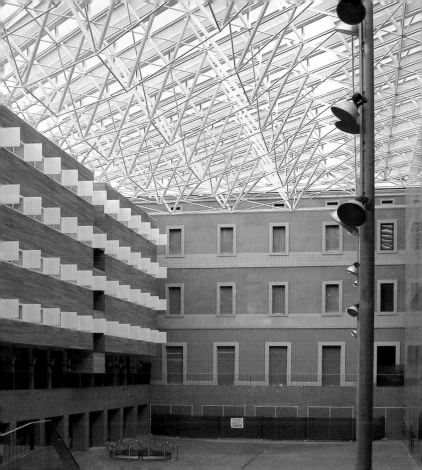

L'Auditori
Concert Hall

Rafael Moneo

1999
Carrer de Lepant, 150
Eixample

www.auditori.org

Due to a lack of reference points in the direct surroundings, the building orients itself on the Eixample district grid and thus takes over the role of an entire block of houses. It includes a concert hall for chamber music and one for a symphony orchestra. An intimate pillar structure made of concrete with panelling made of stainless steel creates the facade.

Mangels Referenzpunkten in der direkten Umgebung orientiert sich das Gebäude an dem Raster des Stadtteils Eixample und übernimmt so die Rolle eines ganzen Häuserblocks. Es beinhaltet einen Konzertsaal für Kammermusik und einen für Symphonieorchester. Eine angedeutete Säulenstruktur aus Beton mit Paneelen aus Edelstahl bildet die Fassade.

Faute de points de référence à proximité immédiate, l'immeuble s'adapte à la trame du quartier Eixample, prenant ainsi en charge le rôle de tout un bloc d'immeubles. Il héberge une salle de concerts pour musique de chambre et un orchestre de symphonies. Une structure esquissée des colonnes en béton aux panneaux en acier spécial constitue la façade.

A falta de puntos de referencia en las inmediaciones, el edificio se orienta según la trama del barrio Eixample y asume así el papel de todo un bloque de casas. Alberga una sala de conciertos para música de cámara y una sala para una orquesta sinfónica. La fachada consta de una estructura de hormigón con paneles de acero que simulan columnas.

70

Galeria Alicia Ventura

Archikubik, Marc Chalamanch,
Miquel Lacasta, Carmen Santana

2002
Carrer d'Enric Granados, 9
Eixample

www.archikubik.com

The gallery is composed of three functional areas that are interwoven with each other. The exhibition area is oriented toward the street; through the recessed dadoes, its walls seem to float in space. The exhibition warehouse, including a gallery, follows. The actual business activities take place in a half-open office area.

Die Galerie besteht aus drei miteinander verwobenen Funktionsbereichen. Der Schauraum ist zur Straße hin orientiert, seine Wände scheinen durch den zurückversetzten Sockelbereich im Raum zu schweben. Darauf folgt das Ausstellungslager mit Galerie. Das eigentliche Geschäftsleben findet im halboffenen Bürobereich statt.

La galerie est composée de trois espaces fonctionnels imbriqués. La salle d'exposition est orientée vers la rue, ses parois semblent flotter dans la pièce, à travers le socle en retrait. L'entrepôt d'exposition avec la galerie y est directement rattaché. Les affaires au sens propre se font dans l'espace de bureaux mi-ouvert.

La galería consta de tres áreas funcionales entrelazadas. La sala de exposición está orientada hacia la calle, y sus paredes parecen flotar en la parte de los zócalos desplazada hacia atrás. A continuación sigue el almacén de exposición con una galería. La actividad comercial propiamente dicha se desarrolla en la zona medio abierta de las oficinas.

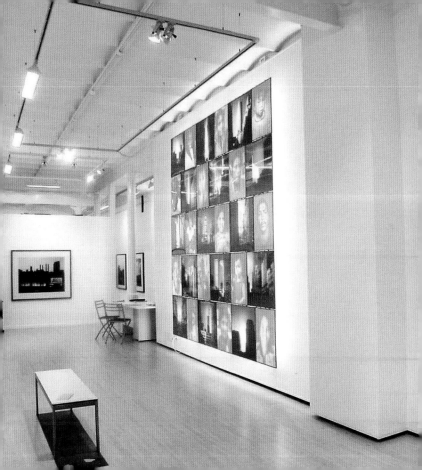

Biblioteca Vila de Gràcia

Vila de Gràcia Library

Josep Llinàs Carmona, Joan Vera García
Jordi Bernuz Bertolín (SE)

2002
Carrer del Torrent de l'Olla, 104
Gràcia

The premise in the Gràcia district on the main axis to the centre is relatively small and is accompanied by residential buildings. In order to preserve the official and representative character desired for the library the building clearly stands out from the neighboring houses through its volume-emphasized architectural symbolism.

Das Grundstück im Stadtteil Gràcia, an der Hauptachse zum Zentrum, ist relativ klein und wird von Wohnbauten begleitet. Um den für die Bibliothek gewünschten offiziellen und repräsentativen Charakter zu erhalten, grenzt sich das Gebäude in seiner volumenbetonten Formensprache deutlich von den benachbarten Häusern ab.

Le terrain dans le quartier Gràcia, sur l'axe principal menant au centre, est relativement petit et accompagné d'immeubles d'habitation. En vue de conserver le caractère sciemment officiel et représentatif de la bibliothèque, le langage des formes de l'immeuble mettra l'accent sur le volume se démarque nettement des immeubles avoisinants.

El terreno en el barrio de Gràcia, situado en el eje central hacia el centro urbano, es relativamente pequeño y está salpicado de edificios de viviendas. Con objeto de conservar el carácter oficial y representativo que ha de exhalar una biblioteca, el edificio se diferencia claramente de las casas adyacentes gracias a su lenguaje de formas voluminosas.

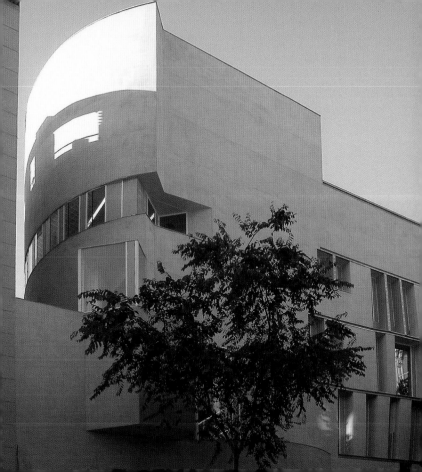

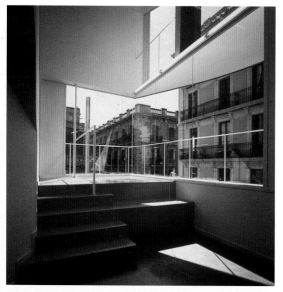

Instituto Botanico
Botanical Institute

Carlos Ferrater

2003
Passeig del Migdia
Sants-Montjuïc

www.ferrater.com

The botanic institute is constructed like a horizontal beam that seems to float over the inclined terrain. The scientific rooms are accommodated at the very top. The botanic collection is found under the glassed in café in the ground floor, which is exposed to light via the inner courtyard.

Das botanische Institut ist wie ein horizontaler Balken konstruiert, der über dem geneigten Gelände zu schweben scheint. Ganz oben sind die wissenschaftlichen Räumlichkeiten untergebracht. Unter dem verglasten Erdgeschoss mit Café befindet sich die botanische Sammlung, die über Innenhöfe belichtet wird.

L'institut botanique a été construit sous comme une poutre horizontale qui semble flotter au-dessus du terrain en pente. Les locaux scientifiques se trouvent au dernier étage. En dessous du rez-de-chaussée tout en verre avec son café a été aménagée la collection botanique qui est éclairée via les cours intérieures.

El Instituto Botánico está construido en forma de barra horizontal que parece flotar sobre el terreno inclinado. Arriba del todo están ubicadas las salas de investigación científica. Debajo de la planta baja acristalada que dispone de una cafetería está alojada la colección botánica iluminada por la luz que penetra desde los patios interiores.

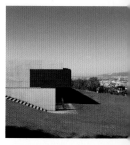

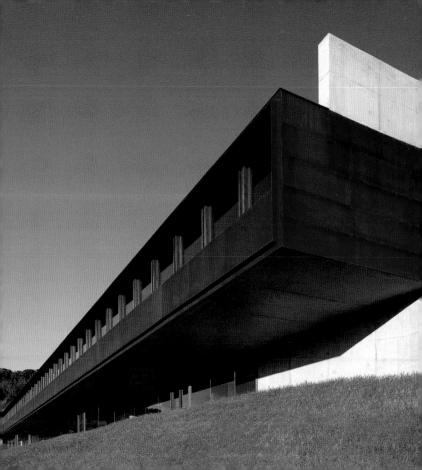

Parque de Diagonal Mar

Park Diagonal Mar

Miralles & Tagliabue Arquitectes Associats
Europroject Ingeniería – José María Velasco (SE)

2002
Carrer de la Selva de Mar /
C. de Llull /
C. de Josep Pla
Sant Martí

www.mirallestagliabue.com

The park plays the role of a direct connecting route between Avinguda Diagonal and the sea, promoting interaction between the city and the beach. It is divided through a series of paths that stretch in all directions just like the branches of a tree. The main path crosses the coastal road using a pedestrian bridge.

Der Park stellt eine direkte Wegeverbindung zwischen der Avinguda Diagonal und dem Meer dar und fördert dadurch die Interaktion von Stadt und Strand. Gegliedert wird er durch eine Reihe von Wegen, die sich gleich den Ästen eines Baumes in alle Richtungen erstrecken. Der Hauptweg überquert die Küstenstraße mittels einer Fußgängerbrücke.

Le parc constitue une liaison directe de chemin entre l'Avinguda Diagonal et la mer, favorisant ainsi l'interaction entre la ville et la plage. Il est structuré par toute une série de chemins qui s'étendent, tels les branches d'un arbre, dans toutes les directions. Le chemin principal traverse la rue côtière par un pont piéton.

El parque establece la conexión directa entre la Avinguda Diagonal y el mar y fomenta así la interacción entre la ciudad y la playa. Se halla subdividido por una serie de caminos que se extienden en todas las direcciones a semejanza de las ramas de los árboles. El camino principal atraviesa el paseo marítimo a través de un puente peatonal.

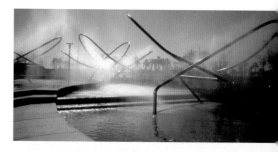

Estaciones Marítimas Internacionales

International Harbor Stations

Rafael de Cáceres i Zurita
Nilo Lletjós (SE)

1998
Moll de Barcelona
Ciutat Vella

With its very formal design basis, connecting the ship moorings to the World Trade Center after the fact was a complex task. It was responded to by extending some of the design elements of the existing building, which disperse into a rhythmic, industrial structural steel construction in its further progression.

Die Schiffsanleger nachträglich an das World Trade Center mit seinen starken formalen Vorgaben anzuschließen war eine komplexe Aufgabe. Sie wurde durch das Verlängern einiger konstruktiver Elemente des bestehenden Gebäudes beantwortet, die sich im weiteren Verlauf zu einer rhythmischen, industriellen Stahlkonstruktion auflösen.

Relier, à posteriori, les embarcadères au World Trade Cent malgré les strictes contraint de forme, fut une tâche comple xe. Elle a été accomplie par prolongation de quelques él ments faisant partie de la co struction de l'immeuble exista qui, par la suite, se dissolve pour composer une constru tion d'acier rythmique et indu trielle.

La posterior construcción de la dársena junto al World Trade Center con sus características estrictamente formales supuso una tarea compleja. La solución fue prolongar algunos elementos constructivos del edificio existente, que más adelante se disuelven en una construcción rítmica de acero de estilo industrial.

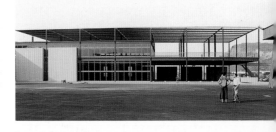

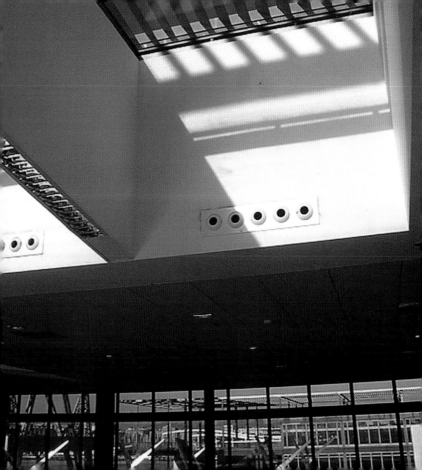

Forum 2004

34. Building and Plaza
for the Forum
Herzog & de Meuron

2004
Sant Martí / Sant Adrià del Besòs

www.barcelona2004.org

On a coastal area on the outermost edge of the city, one finds the venue for the international "Forum 2004" cultural event. One main element is the triangular forum building, which has a subterranean connection to a new convention centre on the other side of the street. The coastal park belongs to a public bathing area.

Auf einem Küstengelände am äußersten Stadtrand befindet sich der Austragungsort für die internationale Kulturveranstaltung „Forum 2004". Ein Hauptelement ist das dreieckige Forumsgebäude, welches unterirdisch mit dem neuen Kongresszentrum auf der anderen Straßenseite verbunden ist. Dem Küstenpark ist ein öffentlicher Badebereich zugeordnet.

Le lieu des manifestations cult relles internationales « Foru 2004 » se trouve sur un terra près de la côte à la périphérie la ville. Le bâtiment triangulaire forum, relié sous terre au no veau centre de congrès à l'aut côté de la rue, en constitu l'élément principal. Le parc de côte dispose d'un espace d baignade public.

En un terreno costero en la periferia de la ciudad se encuentra el lugar de celebración del acto cultural internacional "Forum 2004". Uno de los elementos principales es el edificio triangular del foro, que está conectado subterráneamente con el nuevo centro de congresos en el otro lado de la calle. El parque costero dispone de una zona pública de baño.

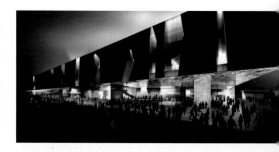

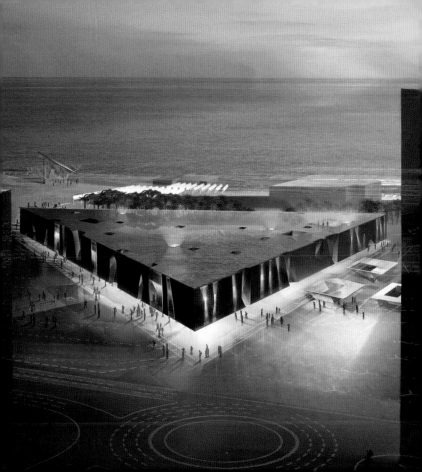

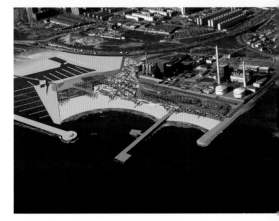

35. Coast Park
Iñaki Abalos, Juan Herreros
Obiol y Moya (P; I; C; A) /
Nilo Lletjós (SE)

2004

www.barcelona2004.org

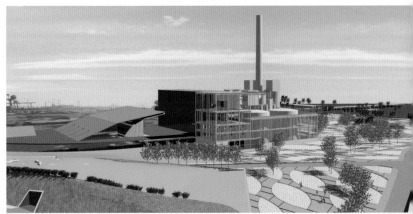

36. **International Convention
 Center**
MAP Arquitectes Josep Lluís Mateo
Obiol, Moya y asociados (SE)

2004

www.mateo-maparchitect.com
www.barcelona2004.org

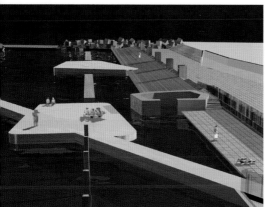

37. **Pangea Island, Swimming Area**
Beth Galí
Jaume Benavent
Infraestructuras (SE)

2004

www.barcelona2004.org

Jardin Botanico

Botanical Garden

Carlos Ferrater

1999
Passeig del Migdia
Sants-Montjuïc

www.ferrater.com

The 15-hectare development creates a large amphitheatre oriented to the southwest. A triangular grid serves as a base structure. Thus, only a slight amount of earth moving had to be carried out. The plants are arranged in the garden according to their geographic characteristics and biological relationships.

Die 15 Hektar große Anlage bildet ein großes, nach Südwesten orientiertes Amphitheater. Als Basisstruktur diente ein dreieckiges Raster, so mussten nur geringfügige Erdbewegungen ausgeführt werden. Die Pflanzen sind entsprechend ihrer geografischen Eigenschaften und biologischen Verwandtschaft im Garten angeordnet.

Cet espace de 15 hectare constitue un grand amphithéâtr orienté vers le sud-ouest. Un trame triangulaire servait d structure de base, ne nécessitar ainsi que des terrassements m nimes. Les plantes ont été ar rangées dans le jardin en fonc tion de leurs propriétés géo graphiques et leurs apparenté biologiques.

Esta instalación con una superficie de 15 hectáreas forma un gran anfiteatro orientado hacia el sudoeste. Como estructura básica se utilizó una trama triangular, de forma que sólo se tuvieron que realizar escasos movimientos de tierras. Las plantas se han dispuesto en el jardín atendiendo a sus características geográficas y su parentesco biológico.

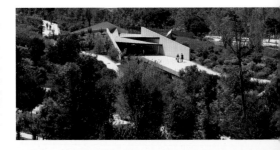

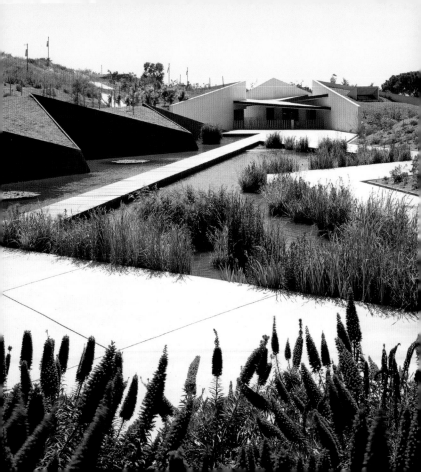

Parque central de Nou Barris

Central Park of Nou Barris

Andreu Arriola, Carmen Fiol
Obiol (SE)

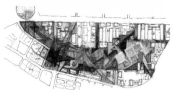

2003
Carrer de Marie Curie, 20
Nou Barris

www.arriolafiol.com

The residential area in the northern part of Barcelona was erected during the 1960's and 70's but its extent could hardly be grasped up to now. This project ties the unclear city areas and the structural masses together into a clearly defined and identifiable urban scene.

Das Wohngebiet im Norden Barcelonas wurde während der 1960er und 70er Jahre errichtet, seine Dimension war jedoch bisher kaum zu erfassen. Dieses Projekt verbindet die unklaren Stadträume und die Gebäudemassen zu einer klar definierten und identifizierbaren urbanen Landschaft.

Le quartier résidentiel au nord de Barcelone a été construit dans les années 1960 et 70, mais jusqu'à présent, ses dimensions étaient pratiquement impossibles à cerner. Ce projet regroupe les espaces urbains diffus et les masses des bâtisses en un paysage urbain identifiable et nettement défini.

La zona residencial en el norte de Barcelona se estableció durante los años sesenta y setenta del siglo pasado, pero no ha sido posible hasta ahora determinar sus dimensiones exactas. Este proyecto fusiona la zona urbana indefinida y las masas de edificios en un paisaje urbano claramente delimitado e identificable.

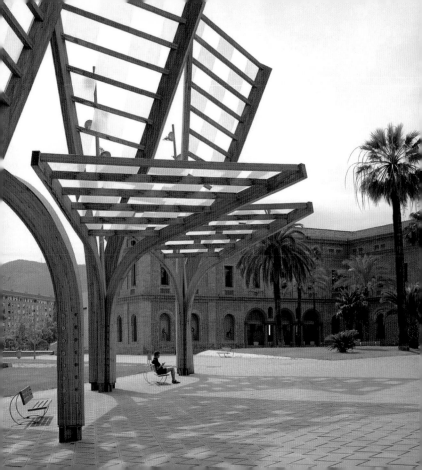

Square above Gran Via

Sergi Godia Fran, Berta Barrio Uría Arquitectos
Europroject Ingeniería – José María Velasco (SE)

2000
Gran Via de les Corts Catalanes
Sant Adrià del Besòs

The square connects both parts of the Sant Adrià del Besòs city quarters together again after having been long separated from another through a motorway. Different from a bridge, which could merely have solved the access problem, the square acts as a linking meeting point and a place to stop.

Der Platz verbindet die beiden seit langem durch eine Schnellstraße voneinander getrennten Teile des Stadtviertels Sant Adrià del Besòs wieder miteinander. Anders als eine Brücke, die lediglich das Erschließungsproblem lösen könnte, fungiert der Platz auch als verknüpfender Treffpunkt und Aufenthaltsort.

La place relie de nouveau le deux parties du quartier Sa Adrià del Besòs qui ont été se parées pendant longtemps pa une route à trafic accéléré. Co trairement à un pont qui ne sa rait résoudre que le seul proble me d'accès, la place fonctionn également de point de rencon tre convivial invitant à s'y atta der un moment.

La plaza conecta las dos partes del barrio de Sant Adrià del Besòs, que desde hacía tiempo se hallaban separadas una de otra por una autovía. A diferencia de un puente, que únicamente solucionaría el problema del acceso, la plaza actúa como punto de encuentro y reunión conjunto.

Parque de la Solidaridad

Park Solidaridad

M.M.A.M.B Espai Públic, Sergi Godia Fran, Xavier Casas Galofré
Gerardo Rodríguez (SE)

1998
Avinguda Ciutat D'Hospitalet /
C. Maria Aurèlia Capmany /
C. Lleialtat /
C. Tierno Galvan
Esplugues de Llobregat

Over a ring road, the park connects the Can Clota and Can Vidalet city districts, which belong to Esplugues de Llobregat. The main axis is created by the central grass strip, which is defined by two footpaths. Both lateral park areas offer room for sports grounds.

Über eine Ringstraße hinweg verbindet der Park die zu Esplugues de Llobregat gehörigen Stadtteile Can Clota und Can Vidalet miteinander. Die Hauptachse bildet der zentrale Rasenstreifen, der durch zwei Fußwege definiert ist. Die beiden seitlichen Parkbereiche bieten Platz für Sportanlagen.

C'est par un périphérique que parc relie les quartiers Can Clo et Can Vidalet faisant partie d l'Esplugues de Llobregat. L'ax principal est composé de la bar de centrale de pelouse défin par deux grands trottoirs. Le deux grands espaces latérale du parc offrent de la place pou des aménagements sportifs.

El parque conecta los barrios de Can Clota y Can Vidalet pertenecientes a Esplugues de Llobregat a través de una avenida de circunvalación. El eje principal lo conforma el tramo central de césped delimitado por los dos caminos. Las dos zonas laterales del parque ofrecen espacio suficiente para diversas instalaciones deportivas.

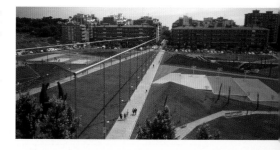

to stay . hotels

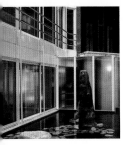
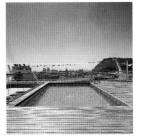
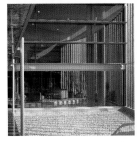
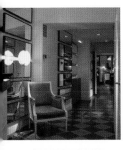
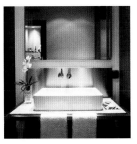
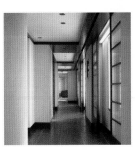
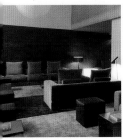
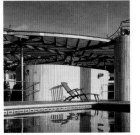
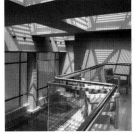

Hotel Neri

Cristina Gabás
JG y Asociados (SE)

2003
Carrer Sant Sever, 5
Ciutat Vella

www.hotelneri.com

The Neri is integrated into a palace from the 18th century. A very private atmosphere prevails in the very straightforward 22-room hotel. The historic substance was handled with respect during reconstruction and supplemented by artistically clear but nevertheless warm and harmonious fittings.

Das Neri ist in einen Palast aus dem 18. Jahrhundert integriert. In dem mit 22 Zimmern sehr überschaubaren Haus herrscht eine private Atmosphäre. Die historische Substanz wurde bei dem Umbau respektvoll behandelt und durch gestalterisch klare, aber dennoch warme und harmonische Einbauten ergänzt.

Le Neri est intégré dans un palais du 18e siècle. Avec une capacité très restreinte de 22 chambres, cet hôtel offre une atmosphère familiale. Lors de sa reconstruction, la substance historique a été traitée avec respect, le complétant ainsi par des éléments intégrés à la conception claire, mais toujours chaleureux et harmonieux.

El Neri se ha integrado en un palacio del siglo XVIII. En esta casa muy abarcable con sus 22 habitaciones reina un ambiente privado. Durante los trabajos de reforma, la sustancia histórica se trató con respecto, complementándose con estructuras de diseño purista por una parte, pero cálidas y armónicas, por otro.

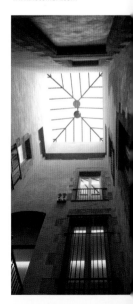

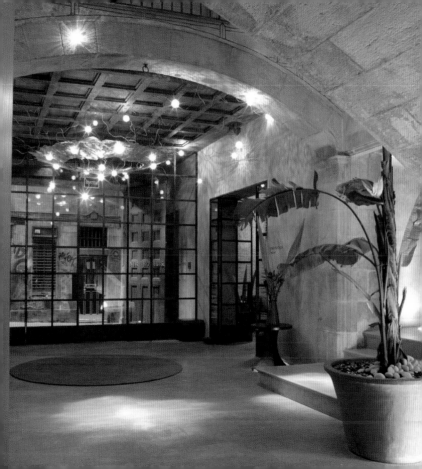

Hotel Banys Orientals

Lazaro Rosa

2000
Carrer de l'Argenteria, 37
Ciutat Vella

www.hotelbanysorientals.com

The Hotel Banys Orientals lies in the centrally situated Born city district near the cathedral and the Gothic quarter. The modern interior architectural concept is integrated in a comfortable old building. The clearly arranged hotel consists of 45 guest rooms and a restaurant.

Das Hotel Banys Orientals liegt im zentralen Stadtteil Born, in der Nähe der Kathedrale und des Gotischen Viertels. Das moderne innenarchitektonische Konzept ist in einen gemütlichen Altbau integriert worden. Das übersichtliche Haus besteht aus 45 Gästezimmern und einem Restaurant.

L'hôtel Banys Orientals est situé dans le quartier central Born, à proximité de la cathédrale et du quartier gothique. Le concept moderne de la décoration intérieure a été intégré dans une construction chaleureuse d'avant-guerre. Cet hôtel d'une capacité restreinte dispose de 45 chambres et d'un restaurant.

El Hotel Banys Orientals se halla en el barrio central Born, cerca de la catedral y del Barrio Gótico. El concepto de un diseño interior moderno se ha integrado en el acogedor edificio antiguo. Esta pequeña casa posee 45 habitaciones y un restaurante.

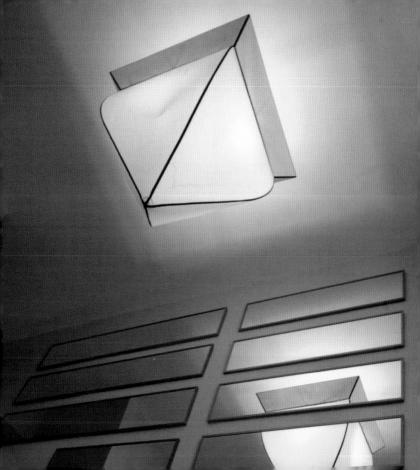

Hotel Arts Barcelona

Skidmore, Owings & Merill
Robert Brufau (SE)

1992
Carrer de la Marina, 19-21
Ciutat Vella

www.ritzcarlton.com/hotels/
barcelona

A total of 455 guest rooms on 44 floors, conference rooms with up to 1700 seats; the dimensions of the immense Hotel Arts, which stands in the middle of the Olympic village, are overwhelming. The facades of the 155-meter high tower drop behind the freestanding steel supporting structure.

Ganze 455 Gästezimmer auf 44 Etagen, Konferenzräume mit bis zu 1700 Plätzen; die Dimensionen des unübersehbaren Hotel Arts, das inmitten des olympischen Dorfes steht, sind gewaltig. Die Fassaden des 155 Meter hohen Turmes bleiben hinter dem freistehenden Stahltragwerk zurück.

Un total de 455 chambres sur 44 étages, des salles de conférence d'une capacité jusqu'à 1700 places ; les dimensions de l'hôtel Arts attirant le regard au milieu du village olympique sont énormes. Derrière l'ossature porteuse isolée en acier, la façade de la tour de 155 mètre reste en retrait.

Un total de 455 habitaciones en 44 pisos, salas de conferencia con hasta 1700 plazas; las dimensiones del inmenso Hotel Arts, ubicado en medio del pueblo olímpico, son simplemente impresionantes. Las fachadas de la torre de 155 metros de altura permanecen al fondo de la estructura portante autoestable de acero.

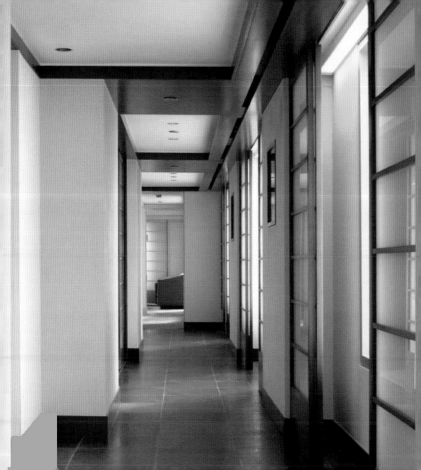

Hotel Habitat Sky

Dominique Perrault
Robert Brufau, Pamias Ingeniería Industrial (SE)

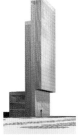

2006
Carrer de Bilbao /
Carrer de Pere IV
Sant Martí

www.habitathoteles.com
www.perraultarchitecte.com

The 27-story high-rise conceived like a sandwich consists of two narrow, vertical opposing structures for the hotel rooms. The easily comprehensible access zone lies in-between. The entrance is punched out of the mass. The restaurant and conference centre are accommodated in the accompanying structure.

Das 27 geschossige, sandwichartig konzipierte Hochhaus besteht aus zwei schlanken, vertikal gegeneinander verschobenen Baukörpern für die Hotelzimmer. Dazwischen liegt die klar ablesbare Erschließungszone. Der Zugang ist aus dem Volumen ausgestanzt. Restaurant und Konferenzzentrum sind in dem begleitenden Baukörper untergebracht.

Le grand immeuble aux 27 étages, d'une conception façon « sandwich » est composé de deux corps longilignes, en translation verticale l'un par rapport à l'autre et destinés aux chambres d'hôtel. La zone d'accès clairement définie se trouve entre eux. L'accès a été découpé du volume. Le restaurant et le centre de conférence sont hébergés dans le corps d'accompagnement.

Este rascacielos de 27 pisos en forma de sandwich consta de dos bloques esbeltos desplazados verticalmente entre sí, que albergan las habitaciones del hotel. Entre los dos bloques se halla la zona de acceso claramente delimitada. La entrada se ha punzonado del volumen del edificio. El restaurante y la sala de conferencias están alojados en el complejo anexo.

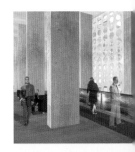

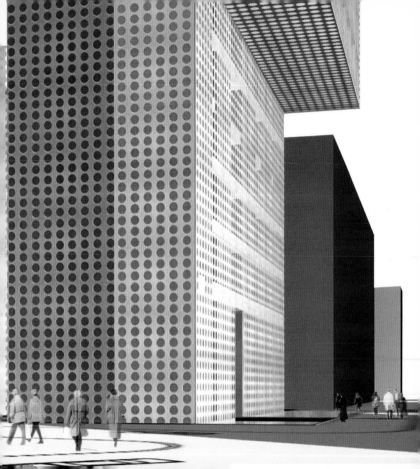

Prestige Hotel
Paseo de Gràcia

Josep Juanpere
GCA Arquitectos (Interior Design)

2002
Passeig de Gràcia, 62
Eixample

www.prestigehotels.com
www.gcaarq.com

The heart of the 45-room hotel is the tasteful, mostly original-preserved stairwell from the 30's. The roof terrace is really beautifully designed; the use of materials divides the roof surfaces and contrast in their colors and haptics.

Herzstück des 45-Zimmer-Hauses ist das stilvolle, weitgehend original erhaltene Treppenhaus aus den 1930er Jahren. Die Dachterrasse ist ausgesprochen schön gestaltet, die verwendeten Materialien gliedern die Dachfläche und kontrastieren in Farbe und Haptik.

La pièce maîtresse de cet hôtel à 45 chambres est la cage d'escalier de style datant des années 30 et en grande partie conservée à l'état d'origine. La conception de la terrasse sur le toit est particulièrement jolie, les matériaux employés divisent la terrasse sur le toit, formant un contraste haptique et de couleur.

El núcleo de esta casa de 45 habitaciones es la elegante escalera de los años 30 del siglo pasado que se ha conservado casi íntegramente en su estado original. La azotea posee una decoración especialmente bonita, y los materiales utilizados subdividen su superficie, mientras que sus colores y su estructura superficial contrastan unos con otros.

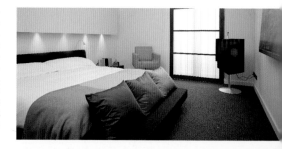

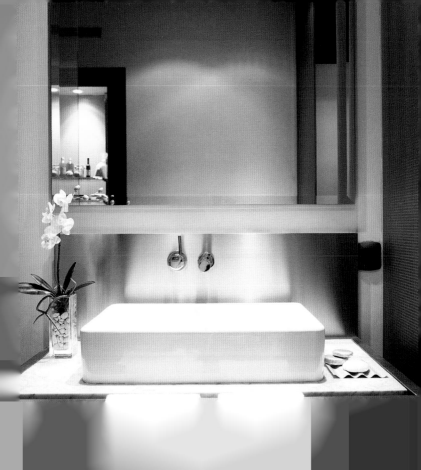

Hotel Omm

Juli Capella
Isabel López, Sandra Tarruella (Interior Design)
Obiol, Moya y Asociados (SE)

2003
Carrer del Rosselló, 265-269
Eixample

www.hotelomm.es
www.capella-arquitectura.com

The cosy little hotel with a view of "La Pedrera" by Antoni Gaudí offers 59 rooms on six floors. Parts of the principle facade curve toward the street like a slightly opened book. The openings are designed so that they ward off the intensive midday sun and the noise from the street.

Das gemütliche kleine Hotel, mit Blick auf „La Pedrera" von Antoni Gaudí, bietet 59 Zimmer auf sechs Stockwerken. Wie ein leicht geöffnetes Buch wölben sich Teile der Hauptfassade zur Straße hin. Die Öffnungen sind so gestaltet, dass sie die intensive Mittagssonne und den Geräuschpegel der Straße abhalten.

Le chaleureux petit hôtel offran une vue sur « La Pedrera d'Antoni Gaudí dispose de 5 chambres sur six étages. Tel u livre légèrement ouvert, certai nes parties de la façade princ pale se penchent vers la rue voûtées. Les ouvertures ont été conçues de sorte que la péné tration du soleil intense de mic et du bruit de la rue soit évitée

Este pequeño y acogedor hotel con vistas sobre "La Pedrera" de Antoni Gaudí ofrece 59 habitaciones distribuidas en seis pisos. Parte de la fachada principal se arquea como un libro ligeramente abierto hacia la calle. Los orificios se han diseñado de tal forma que absorban la luz intensa del mediodía y los ruidos de la calle.

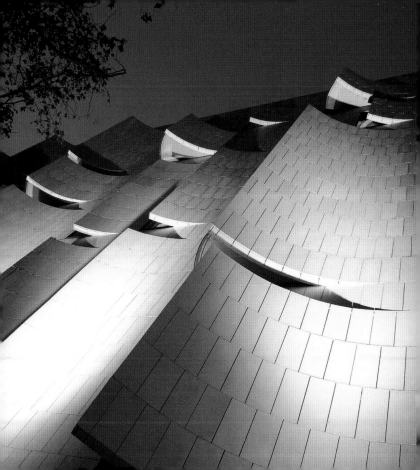

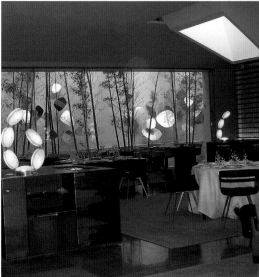

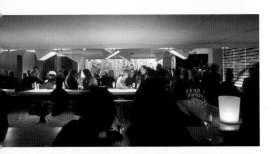

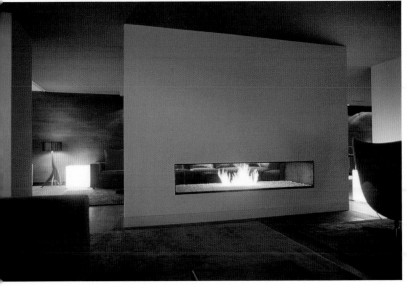

Hotel Claris

MBM Arquitectes

1991
Carrer de Pau Claris, 150
Eixample

www.derbyhotels.es
www.mbmarquitectes.com

Only the facade was preserved during the five-year long reconstruction of the townhouse originally constructed in 1892. Generous glazing allows the passer-by glances into the modern lobby made out of steel, copper, glass, and concrete. More than 300 partially antique art treasures from the house-own collection are exhibited in the hotel.

Bei dem fünf Jahre dauernden Umbau des 1892 erbauten Stadthauses wurde lediglich die Fassade erhalten. Großzügige Verglasungen erlauben dem Passanten Einblicke in die moderne Lobby in Stahl, Kupfer, Glas und Beton. Im Hotel sind mehr als 300 teils antike Kunstschätze aus der hauseigenen Sammlung ausgestellt.

Seulement la façade fut conservée lors de la reconstruction sur cinq ans de l'hôtel de ville construit en 1892. De grandes vitres permettent au passant de jeter un regard dans le vestibule moderne en acier, cuivre, verre et béton. Plus de 300 trésors d'art, dont quelques antiquités, faisant partie de la collection de l'hôtel, y sont exposés.

Lo único que se ha conservado después de los cinco años de reformas de la casa urbana construida en 1892 es la fachada. Las amplias cristaleras le permiten al pasante echar un vistazo al moderno hall de acero, cobre, cristal y hormigón. En el hotel se exponen más de 300 tesoros artísticos, parte de ellos antiguos, de la colección propia.

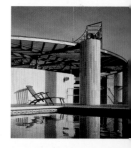

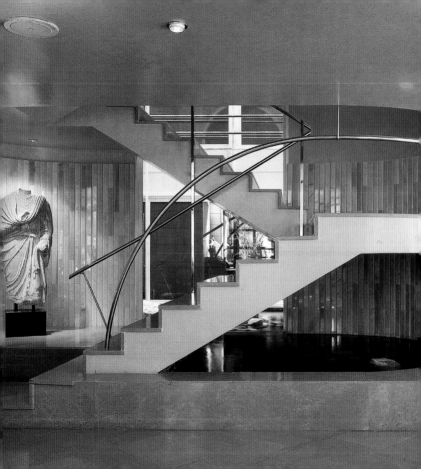

Gran Hotel la Florida

Dale Keller
Ramón Raventós (Original Building 1925)

2003
Carretera de Vallvidrera al Tibidabo
83-93
Sarrià-Sant Gervasi

www.hotellaflorida.com

One of the most historic buildings in Barcelona shines in new glory after a four-year reconstruction period. Remarkable for so small a house is the 37-metre long pool that leads into the open from a modern addition and offers a panoramic view over the city and of the ocean.

Eines der traditionsreichsten Häuser Barcelonas erstrahlt nach vierjähriger Umbauzeit nun wieder in neuem Glanz. Für ein so kleines Haus bemerkenswert ist der 37 Meter lange Pool, der aus einem modernen Anbau heraus ins Freie führt und eine Panoramaaussicht über die Stadt und auf das Meer bietet.

L'un des pavillons riche d'une des plus longues histoires de Barcelone rayonne de nouveau dans toute sa splendeur après quatre ans de reconstruction. Ce qui est remarquable pour un pavillon si petit, c'est la piscine d'une longueur de 37 mètres menant d'un annexe moderne à l'air libre et offrant une vue panoramique sur la ville et la mer.

Una de las casas más tradicionales de Barcelona vuelve a relucir con nuevo brillo tras cuatro años de reformas. En esta casa tan pequeña llama la atención la piscina de 37 metros de largo, que conduce del interior del moderno anexo al exterior y ofrece una vista panorámica sobre la ciudad y el mar.

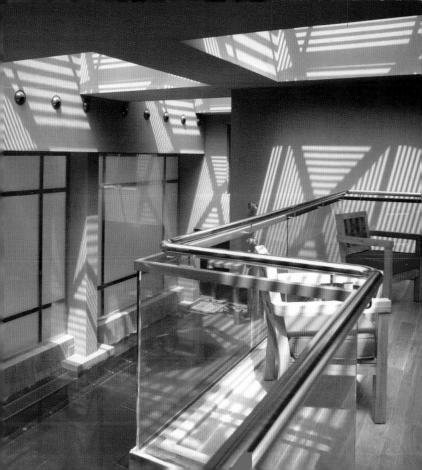

Grand Marina Hotel

Pei Cobb Freed & Partners Architects LLP, GCA Arquitectos
MC-2 Estudio de Ingeniería IOC (SE)

2002
Moll de Barcelona
Ciutat Vella

www.grandmarinahotel.com
www.pcf-p.com

The Grand Marina Hotel is located in the middle of Barcelona's old harbor and is connected with the city centre via an avenue found on the pier. It occupies the fourth eight-floor World Trade Center structure. The exhibited art works are part of the house-own contemporary collection.

Das Hotel Grand Marina befindet sich mitten in Barcelonas altem Hafen und ist über eine auf dem Pier befindliche Allee mit der Innenstadt verbunden. Es belegt den vierten, achtgeschossigen Baukörper des World Trade Centers. Die ausgestellten Kunstwerke sind Teil der hauseigenen zeitgenössischen Sammlung.

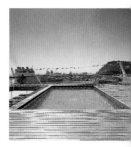

L'hôtel Grand Marina se trouve en plein cœur du vieux port de Barcelone et est relié au centre ville par une allée se trouvant sur le môle. Il occupe le quatrième corps à huit étages du World Trade Center. Les objets d'art exposés font partie de la collection de l'art contemporain appartenant à l'hôtel.

El Hotel Grand Marina se encuentra en medio del puerto antiguo de Barcelona y está conectado con el centro de la ciudad a través de una avenida que hay en el muelle. Ocupa el cuarto bloque de ocho pisos del World Trade Center. Las obras de arte expuestas pertenecen a la colección de arte moderno propiedad del hotel.

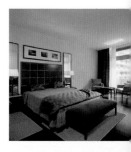

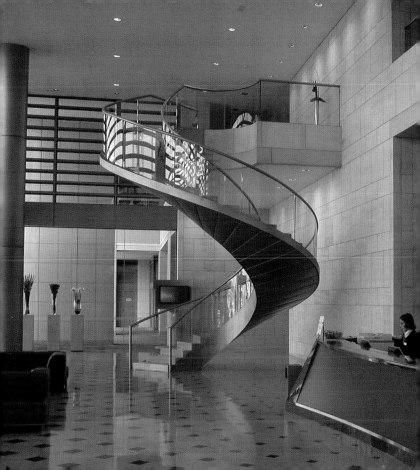

Hotel Capital

Julio Pérez Català
PGI Grup (SE)

2001
Carrer Arquitectura, 1
Hospitalet de Llobregat

www.hotel-capital.com

The Capital is an oasis of tranquillity in the midst of the hectic bustle of the metropolis. A curtain of wooden louvers encases the entire entrance area and lends the foyer an almost meditative ambience. In the open portion of the lobby there is a large water basin spanned by a footbridge.

Eine Oase der Ruhe inmitten der hektischen Betriebsamkeit der Metropole ist das Capital. Ein Vorhang aus hölzernen Lamellen hüllt den gesamten Eingangsbereich ein und verschafft dem Zugang ein fast schon meditatives Ambiente. Im Freibereich der Lobby befindet sich ein großes Wasserbecken, das von einem hölzernen Steg überspannt ist.

Le Capital constitue un oasis de calme en plein cœur de l'activité affairée de la métropole. Un rideau en lamelles en bois habille tout l'espace d'entrée et confère à l'accès une atmosphère invitant presque à la méditation. Dans l'espace libre du vestibule se trouve un grand bassin d'eau sur lequel est tendue une passerelle en bois.

El Capital es un oasis de tranquilidad en medio de la frenética actividad de la metrópoli. Una cortina de láminas de madera rodea la zona completa de la entrada, confiriéndole un ambiente ya casi meditativo. En la zona descubierta del hall hay una gran pila de agua sobre la que discurre una pasarela.

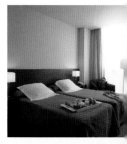

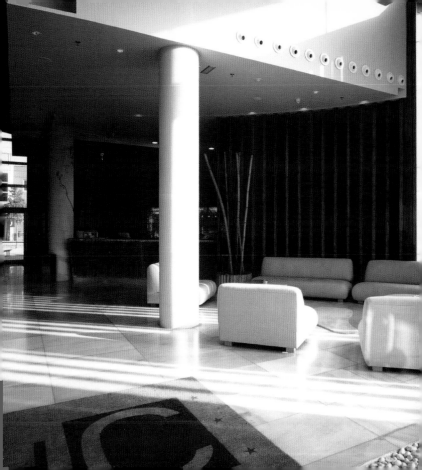

to go . eating
drinking
clubbing
wellness, beauty & sport

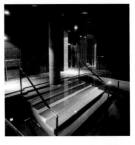

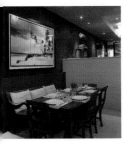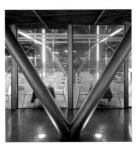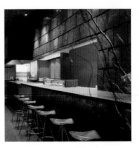

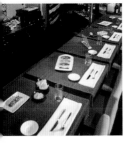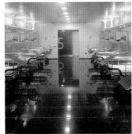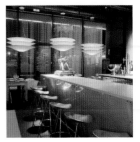

LUPINO
Lounge Restaurant

Ellen Rapelius, Xavier Franquesa

2002
Carrer del Carme, 33
Ciutat Vella

www.stnex.com

The Lupino is a pipe-like multi-space with flexible use and a complex scheme: café, bar, lounge, chill-out, restaurant, casual restaurant, and terrace café. The individual, clearly defined zones flowingly merge into each other. With two entrances and 50 metres in length, the tavern becomes a passage—the transit to a catwalk.

Das Lupino ist ein röhrenartiger Multi-Space mit flexibler Nutzung und vielschichtigem Programm: Café, Bar, Lounge, Chill-out, Restaurant, Casual Restaurant und Terrassencafé. Die einzelnen, klar definierten Zonen gehen fließend ineinander über. Mit zwei Eingängen und 50 Metern Länge wird das Lokal zur Passage, der Durchgang zum Laufsteg.

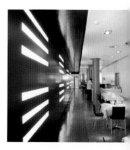

Le Lupino est un espace tubulaire multifonctions aux utilisations multiples et d'un programme varié : café, bar, salon, chill-out, restaurant, restaurant relax, café sur terrasse. On passe d'une zone clairement définie à l'autre, sans transition. Avec ces deux entrées et d'une longueur de 50 mètres, le restaurant devient un passage et celui-ci une passerelle.

El Lupino es un multiespacio tubular de uso flexible que dispone de un programa muy variado: café, bar, lounge, chill-out, restaurante, restaurante casual y café terraza. Los límites de estas diferentes zonas definidas claramente son más bien difusos. Con sus dos entradas y una longitud de 50 metros, el local se transforma así en una galería y el pasillo, en una pasarela.

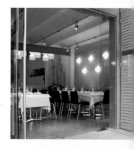

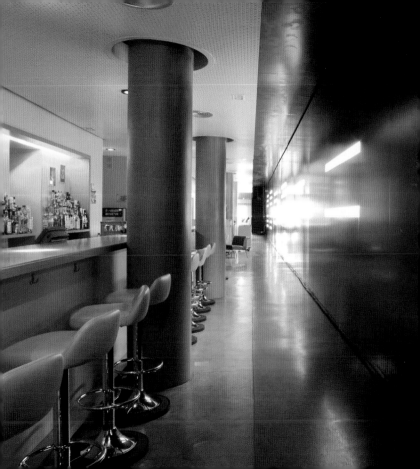

La Sucursal

Joan Marsé, Pascal Frot

2002
Carrer del Comerç, 4
Ciutat Vella

Both the facilities and the kitchen in La Sucursal are very modern and are exemplified by their clearly cut lines. The elegant atmosphere of the restaurant underscores the international cuisine. Here, dishes from several continents are united into interesting meals.

Sowohl die Räumlichkeiten als auch die Küche des La Sucursal sind sehr modern und von einer klaren Linie geprägt. Die elegante Atmosphäre des Restaurants unterstreicht die internationale Küche. Hier werden Speisen von mehreren Kontinenten zu interessanten Menüs vereint.

Les locaux comme la cuisine du La Sucursal sont très modernes et caractérisés par des lignes claires et nettes. L'atmosphère élégante du restaurant souligne la cuisine internationale. Ici, les plats de plusieurs continents sont mélangés pour former des menus intéressants.

Tanto los espacios interiores como la cocina del restaurante La Sucursal son muy modernos y están caracterizados por su clara línea. El elegante ambiente del restaurante subraya la cocina internacional. Aquí se combinan platos de diferentes continentes dando lugar a interesantes menús.

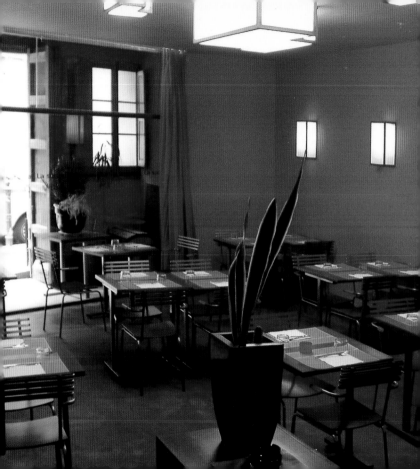

Comerç24

Alfons Tost

2002
Carrer del Comerç, 24
Ciutat Vella

www.comerc24.com

The Comerç24 restaurant, run by Carlos Abellán, is the harmonious interplay of a clear design concept with distinctly innovative cuisine. The dishes are based on a progression of "tapas". This concerns both the traditional Catalan dishes as well as the newly interpreted international creations.

Das von Carlos Abellán geführte Restaurant Comerç24 ist das harmonische Zusammenspiel einer klaren Designkonzeptes mit einer ausgesprochen innovativen Küche. Die Gerichte basieren auf einer Abfolge von „Tapas". Dabei handelt es sich sowohl um traditionelle katalanische Gerichte als auch um neuinterpretierte internationale Kreationen.

Le restaurant Comerç24 géré par Carlos Abellán représente la combinaison harmonieuse entre un concept bien défini et d'une cuisine particulièrement innovatrice. Les plats sont basés sur une suite de « tapas ». Il s'agit alors de plats traditionnels catalans ainsi que de créations de la cuisine internationale d'une interprétation nouvelle.

El restaurante Comerç24 conducido por Carlos Abellán destaca por la armoniosa interacción del concepto decorativo de líneas claras y la cocina especialmente innovadora. Los platos se basan en una serie de "tapas", compuestas por platos catalanes tradicionales y creaciones internacionales con una interpretación propia.

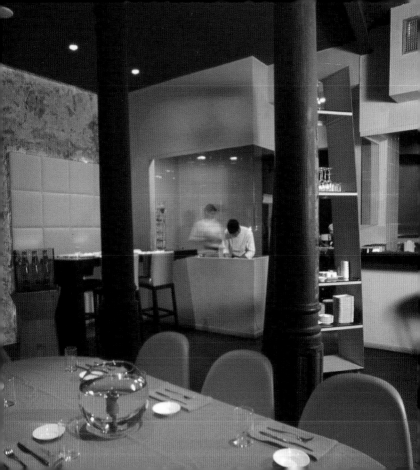

Agua

Isabel López, Sandra Tarruella

1997
Passeig Marítim
de la Barceloneta, 30
Cuitat Vella

www.aguadeltragaluz.com

The appearance of the Agua is distinguished by the furnishings kept in colonial style and its intense association with the beach. Generous glazing and the wooden terrace surfacing that continues into the interior awakens the impression that one is sitting in the open. The menu in the restaurant-tapas-bar is predominantly maritime.

Die Erscheinung des Agua ist von der im Kolonialstil gehaltenen Möblierung und seinem intensiven Bezug zum Strand geprägt. Großflächige Verglasungen und der bis in den Innenraum geführte hölzerne Terrassenbelag erwecken den Eindruck im Freien zu sitzen. Die Karte der Restaurant-Tapas-Bar ist vorwiegend maritim.

C'est le style colonial des meubles et ses références soulignées avec la plage qui composent l'aspect de l'Agua. Les grandes baies vitrées et le revêtement en bois des terrasses qui s'étend jusque dans la salle à l'intérieur donnent l'impression de se trouver à l'air libre. La carte du bar aux tapas du restaurant est essentiellement maritime.

El aspecto del Agua está marcado por los muebles de estilo colonial y su fuerte relación con el mar. Las grandes vidrieras y el pavimento de madera de la terraza que se prolonga hacia el interior crean la sensación de estar sentados al aire libre. La carta de este restaurante-bar de tapas es de carácter preferentemente marítimo.

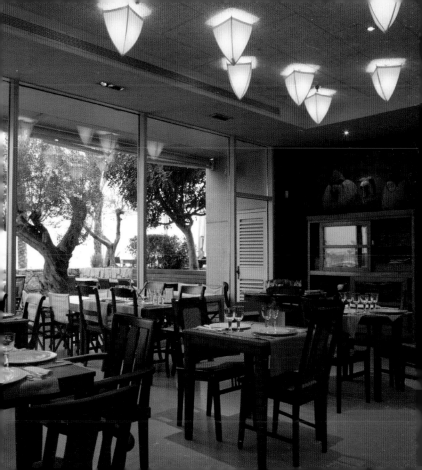

Bestial

Isabel López, Sandra Tarruella

2002
Carrer de Ramon Trias Fargas, 2-4
Ciutat Vella

www.bestialdeltragaluz.com

The naming of the restaurant bar located directly on the beach is derived from Frederic Amat's wall graphic, "bestial bitchos". In the garden area, directly under Frank O. Gehry's metallic fish structure, a light terrace landscape is stacked in which the level jumps can also be used as sitting steps.

Die Namensgebung der direkt am Strand gelegenen Restaurant-Bar leitet sich von Frederic Amats Wandgrafik „bestial bitchos" ab. Im Gartenbereich, direkt unter Frank O. Gehrys metallener Fischkonstruktion, stapelt sich eine leichte Terrassenlandschaft, deren Niveausprünge auch als Sitzstufen genutzt werden können.

Le nom du bar-restaurant se tuant directement à la plage e dérivé du graphique mural Frederic Amat « bestial bitchos Dans le jardin, directement dessous de la construction m tallique aux poissons de Frank Gehry, s'entasse un paysage légères terrasses dont les diff rents niveaux peuvent égaleme servir de marches pour s'y a seoir.

El nombre de este restaurante-bar situado directamente junto a la playa se deriva del mural "bestial bitchos" de Frederic Amat. En la zona del jardín, directamente debajo de la escultura metálica en forma de pez de Frank O. Gehry, se apila un paisaje ligeramente escalonado, cuyos saltos de nivel también pueden utilizarse como asientos.

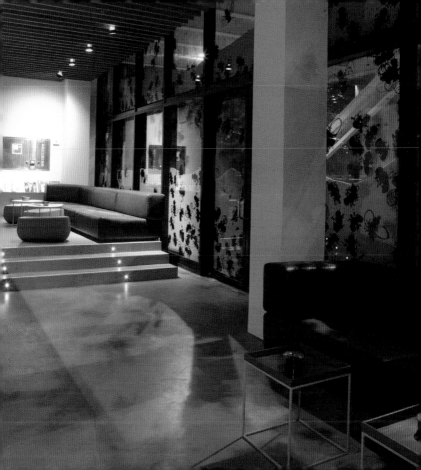

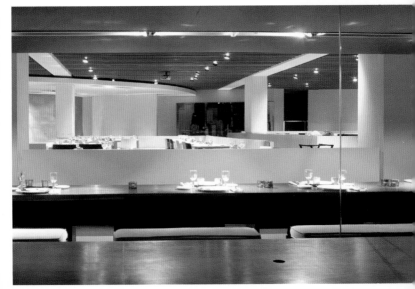

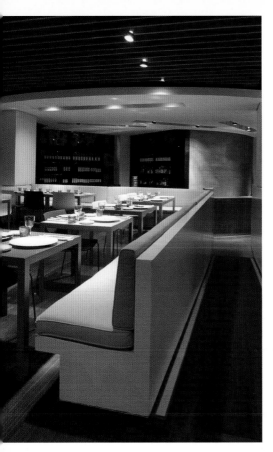

Shoko

Futur-2
Andrés Carcelero (SE)

2004
Passeig Marítim
de la Barceloneta, 36
Ciutat Vella

www.futur-2.com

Five clearly defined areas reflect the elements of Feng-Shui—thus water, wood, metal, earth, and fire. The individual zones differ in material and furnishings as well as their seating arrangements. The room, serving as a restaurant during the day, transforms into a bar in the evening.

Fünf klar definierte Bereiche spiegeln die Elemente des Feng-Shui, also Wasser, Holz, Metall, Erde und Feuer, wider. Die einzelnen Zonen unterscheiden sich in Material und Möblierung sowie der Anordnung der Sitzgelegenheiten. Der Raum, der tagsüber als Restaurant fungiert, verwandelt sich abends in eine Bar.

Cinq zones bien définies reflètent les éléments du feng shui, donc l'eau, le bois, le métal, la terre et le feu. Ces différentes zones se distinguent de par leur matériau et leur ameublement ainsi que par l'arrangement des sièges. La salle qui, le jour, fait fonction de restaurant, se transforme en bar le soir.

Cinco áreas claramente definidas reflejan los elementos del Feng-Shui agua, madera, metal, tierra y fuego. Las diferentes zonas se diferencian en los materiales y en el mobiliario, así como en la disposición de los asientos. El recinto, que de día es un restaurante, de noche se convierte en un bar.

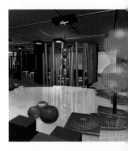

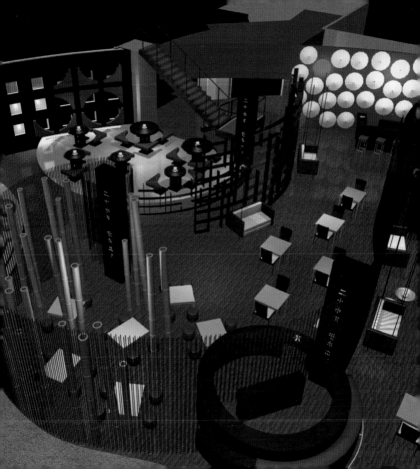

El Principal

Isabel López, Sandra Tarruella

2001
Carrer de Provença, 286-288
Eixample

www.elprincipal.es

The first class El Principal is designed very quietly and functionally. Mobile walls enable small and large areas of the restaurant to be able to be divided into private spheres. However, the facilities can also be used for festivities with up to 500 guests.

Das erstklassige El Principal ist sehr ruhig und sachlich gestaltet. Mobile Wände ermöglichen es, kleine und große Bereiche des Restaurants für eine erhöhte Privatsphäre abzuteilen. Die Räumlichkeiten können aber auch für Feierlichkeiten mit bis zu 500 Gästen genutzt werden.

L'excellent El Principal jouit d'une conception très calme et fonctionnelle. Les cloisons mobiles permettent la division du restaurant en grands et petits espaces pour offrir plus d'intimité. Mais, la salle peut aussi être utilisée à des festivités auxquelles participent jusqu'à 500 invités.

El excelente restaurante El Principal posee una decoración muy tranquila y objetiva. Paredes móviles permiten dividir el restaurante en espacios de mayor o menor tamaño que aumentan la sensación de privacidad. Las salas también se pueden utilizar para celebrar fiestas de hasta 500 invitados.

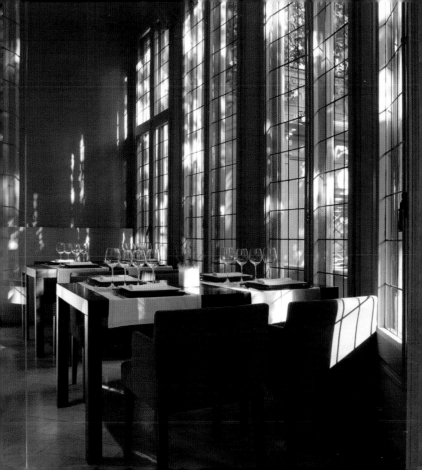

El Japonés

Isabel López, Sandra Tarruella

1999
Passatge de la Concepció, 2
Eixample

www.grupotragaluz.com/japones

The rooms in the in-restaurant El Japonés on the Passeig de Gràcia connect a very clear and contemporary architectural language with classic Japanese elements. Thus, the back of the room is covered with modern interpreted, tatami-like webs made of stainless steel webbing.

Die Räume des In-Restaurants El Japonés am Passeig de Gràcia verbinden eine sehr klare und zeitgenössische Architektursprache mit klassischen japanischen Elementen. So ist die Rückwand des Raumes mit modern interpretierten, tatamiartigen Bahnen aus Edelstahlgewebe bespannt.

Les salles du restaurant à la mode El Japonés au Passeig de Gràcia lient un langage architectural contemporain et très clair aux éléments japonais classiques. Ainsi, la paroi arrière de la salle est revêtu de longueurs d'un tissu en acier spécial d'une interprétation moderne et évoquant des tatamis.

En el espacio interior del restaurante de moda El Japonés en el Passeig de Gràcia se combina el lenguaje arquitectónico actual de líneas muy claras con elementos clásicos japoneses. Así, la pared posterior del interior está revestida de tiras modernas de malla de acero al estilo de tatamis.

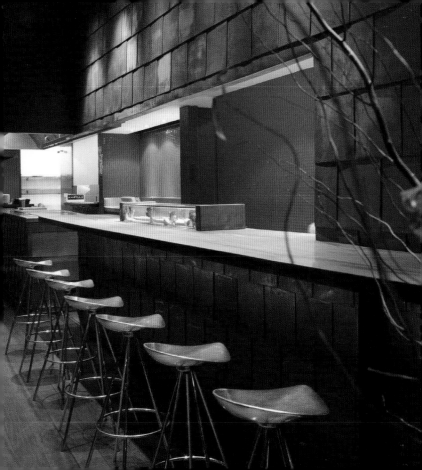

El Negro

Isabel López, Sandra Tarruella

1999
Avinguda Diagonal, 640
Les Corts

www.negrodeltragaluz.com

The calculated, modern ambient of the Negro, a lunch and dinner restaurant, emerges from the interplay of Mediterranean and far eastern traits. Its identity is characterized by light-dark contrasts used throughout. It turns into a music bar with video installations at night.

Das kalkulierte, moderne Ambiente des Negro, einem Mittag- und Abendrestaurant, entsteht aus dem Zusammenspiel mediterraner und fernöstlicher Wesenszüge. Seine Identität ist von durchgängig verwendeten Hell-dunkel-Kontrasten geprägt. Nachts verwandelt es sich in eine Musikbar mit Videoinstallationen.

L'ambiance calculée et moderne du Negro, un restaurant travaillant à midi et le soir, est due à une combinaison de traits méditerranéens et extrême-orientaux. Son identité se distingue par des contrastes entre le clair et le sombre appliqués sans exception. La nuit, il se transforme en bar de musique avec installation vidéo.

El ambiente consecuentemente moderno del Negro, un restaurante de almuerzos y cenas, resulta de la interacción de elementos mediterráneos y de Extremo Oriente. Su identidad está caracterizada por contrastes de tonos claros y oscuros utilizados en toda su extensión. De noche, se convierte en un bar de música con videoinstalaciones.

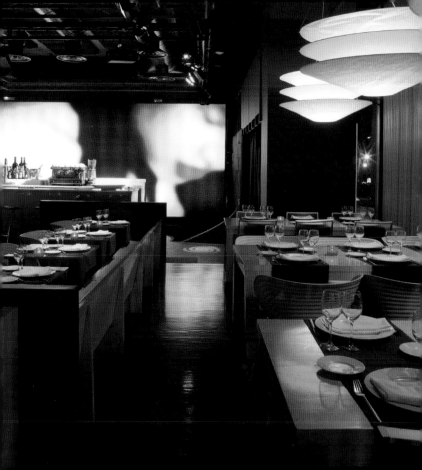

Danzatoria

Andrés Carcelero, Rafael Tamborero

2000
Avinguda del Tibidabo, 61
Sarrià-Sant Gervasi

www.gruposalsitas.com

The Danzatoria is subdivided according to musical aspects. In the highest room, the "Party" area, exclusively musical classics are played; lounge music resonates from the "Hall". If things become too leisurely in the "Chill-out" garden there is still the booming bass sounds in the "Dance" zone.

Die Danzatoria ist nach musikalischen Aspekten gegliedert. Im höchsten Raum, dem „Party"-Bereich, werden ausschließlich musikalische Klassiker gespielt, aus der „Hall" erklingt Loungemusik. Sollte es im „Chill-out"-Garten zu gemütlich werden, bleiben immer noch die wummernden Bässe der „Dance"-Zone.

La Danzatoria est structurée e fonction d'aspects musicau. Dans la pièce la plus élevé l'espace « party », on joue exclu sivement des classiques, alo qu'on entend de la musique d salon dans le « hall ». Ceux q trouvent que le jardin « chill-out est devenu trop accueillant, peu vent toujours se tourner vers le graves bourdonnants de la zon « dance ».

El Danzatoria está estructurado según aspectos musicales. En la sala más alta, la zona de fiestas, se oyen exclusivamente clásicos de la música, mientras que del "hall" resuena música lounge. Si el ambiente en el jardín "chill-out" le resulta demasiado apacible, aún le queda por descubrir la zona de baile en la que repercuten los bajos.

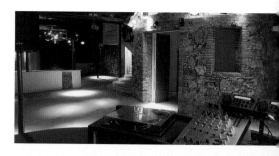

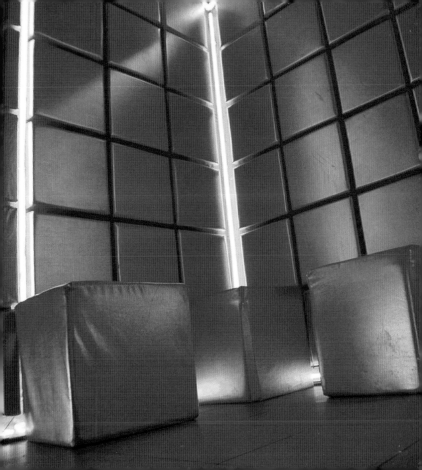

Sandwich & Friends

Francesc Pons

1999
Passeig del Born, 27
Ciutat Vella

www.sandwichandfriends.com
www.estudifrancescpons.com

The design principle is the creation of a well-staged optical chaos. Distractions formed through variously strongly reflecting surfaces, level differences in the floor and ceiling, extensive, and contrasting wall graphics, and isolated, gaudy elements are designed to complicate one's orientation in the room.

Gestalterisches Prinzip ist die Schaffung eines wohlinszenierten optischen Chaos. Irritationen, resultierend aus unterschiedlich stark reflektierenden Oberflächen, Niveauunterschieden in Boden und Decke, großflächigen, kontrastierten Wandgrafiken und vereinzelten knallbunten Elementen, sollen die Orientierung im Raum erschweren.

Le principe de la conceptic repose sur la création d'un chac optique sciemment mis en scèn Des illusions optiques générée par des surfaces aux reflets d'i tensités différentes, des différer ces de niveau du sol et du plafon des graphiques muraux spacieu au contraste et des éléments isc lés aux couleurs vives ont é crées pour rendre l'orientatic plus difficile dans cet espace.

El principio decorativo es crear un caos óptico premeditado. La irritación que generan las superficies con diferente grado de reflexión, las diferencias de nivel de los suelos y techos, los murales de gran formato que contrastan entre sí y los elementos individuales en colores chillones pretenden dificultar la orientación en la sala.

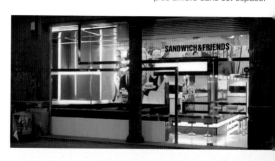

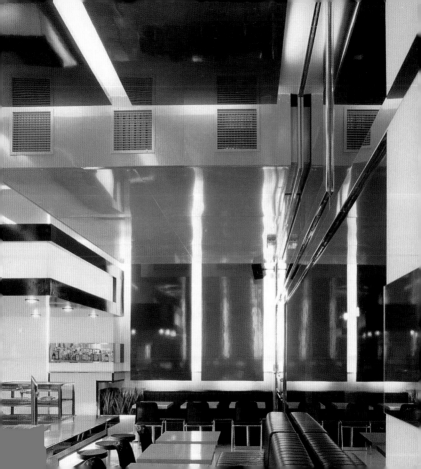

El Jardí

WMA Willy Müller
THB Consulting / Ingeniería Reventos (SE)

2000
Poligono industrial
Mercado de las flores
Zona Franca

www.willy-muller.com

The connecting bridge with a restaurant-café is a belated measure in order to strengthen both the access and gastronomy of the frequently overcrowded covered market. The slightly opposing bulks of the El Jardí are made of aluminum and colored glass.

Die Verbindungsbrücke mit Restaurant-Café ist eine nachträgliche Maßnahme, um gleichzeitig Erschließung und Gastronomie der häufig überfüllten Markthalle zu stärken. Die leicht gegeneinander verschobenen Volumen des El Jardí bestehen aus Aluminium und gefärbtem Glas.

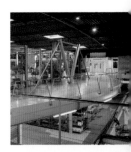

Le pont de jonction comprenant un restaurant café est une mesure introduite à posteriori pour favoriser simultanément l'accès et la gastronomie de la halle de marché souvent comblée. Les volumes du El Jardí, légèrement en translation l'un par rapport à l'autre sont composés d'aluminium et de verre teinté.

La pasarela de comunicación con restaurante-cafetería integrado fue una medida posterior, cuyo objeto era aumentar las posibilidades de acceso y la gastronomía en el mercado frecuentemente abarrotado de gente. Los bloques ligeramente desplazados uno frente a otro de El Jardí, son de aluminio y cristal de color.

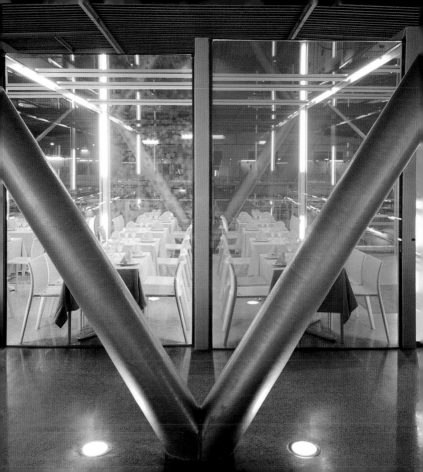

Salon de Belleza "5° 1ª"

Beauty Salon

Francesc Pons

2001
Carrer de Balmes, 5
Eixample

www.estudifrancescpons.com

The salon is subdivided into reception and styling areas by a green plant balustrade. A dressing table placed in the middle lets the room appear to be very spacious. The walls are covered with marble and zebrano, a West African wood, and thus create a noble, dynamic background.

Der Salon ist durch eine grüne Pflanzenbrüstung in Rezeption und Stylingbereich unterteilt. Ein mittig eingestellter Frisiertisch lässt den Raum sehr großzügig erscheinen. Die Wände sind mit Marmor und Zebrano, einem westafrikanischen Holz, verkleidet und erzeugen so einen edlen, dynamischen Hintergrund.

Un parapet vert de plantes div se le salon en un espace récep tion et une salle de coiffure. Ur table de coiffeuse placée au ce tre confère à la salle une in pression très vaste. Les mu sont revêtus de marbre et de z brano, un bois ouest africain, donnent donc un arrière-plan ne ble et dynamique.

Una barandilla decorada con plantas verdes subdivide el salón en recepción y zona de estilismo. Un tocador en el centro agranda ópticamente la sala. Las paredes están revestidas de mármol y cebrano, una madera tropical de África occidental, creando así un fondo elegante y dinámico.

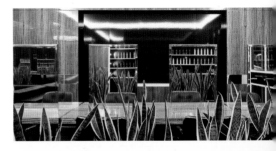

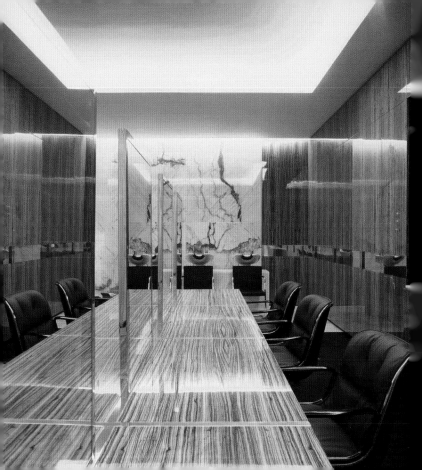

02 Centro Wellness

Wellness Center

Alonso Balaguer y Arquitectos Asociados
Construcciones Rubau (SE)

2002
Passeig de Manuel Girona, 23
Sarrià-Sant Gervasi

www.alonsobalaguer.com

The introverted rooms of the 02 wellness centre in a harmonious color scheme escape the urban surroundings and open themselves only to the view of the adjacent Quinta Amelia Park. The quiet exercise and thermal spring area is mainly in warm quarry stone.

Die introvertierten, in harmonischen Farben gehaltenen Räume des 02-Wellnesscenters entziehen sich dem städtischen Umfeld und öffnen sich einzig den Ausblicken auf den benachbarten Quinta Amelia Park. Der ruhige Übungs- und Thermalbereich ist vornehmlich in warmem Naturstein gehalten.

Les salles revêtant de couleurs harmonieuses et introverties du centre de bien-être 02 se retirent du contexte urbain et s'ouvrent exclusivement à la vue sur le parc Quinta Amelia avoisinant. L'espace calme réservé aux exercices et aux applications thermales est essentiellement aménagé en pierre naturelle de couleurs chaleureuses.

Las salas introvertidas del centro 02 de wellness decoradas en colores armónicos están aisladas del entorno urbano y sólo permiten la vista sobre el cercano Quinta Amelia Park. La mayor parte de la zona de ejercicios y baños termales está decorada con piedra natural de tonalidades cálidas.

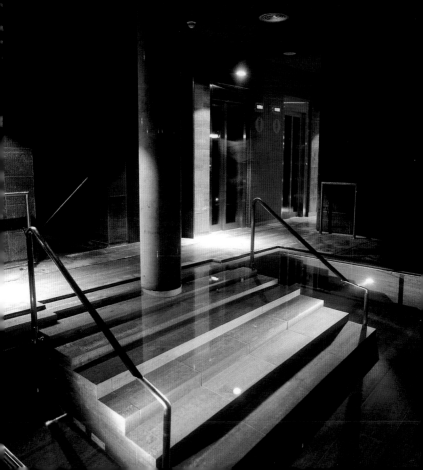

Centro Internacional de Medicina Avanzada (CIMA)

Medical Center

Alonso Balaguer y Arquitectos Asociados
Construcciones Rubau (SE)

2002
Passeig de Manuel Girona, 23
Sarrià-Sant Gervasi

www.alonsobalaguer.com

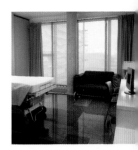

The new facilities of the medical institution were structurally dealt with as a coffer made of glass, which is also meant to transport the image of clinical purity outside. The extensively glassed in double facade offers views of the entire city.

Die neuen Räumlichkeiten der medizinischen Einrichtung wurden baukörperlich wie eine gläserne Kassette behandelt, die das Bild klinischer Reinheit nach außen transportieren soll. Die großflächig verglaste Doppelfassade bietet Ausblicke über die ganze Stadt.

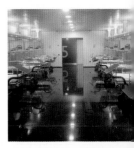

Les nouveaux locaux du centre médical ont été traités, pour ce qui concerne leur corps, comme une cassette en verre qui doit transporter vers l'extérieur l'image d'une propreté clinique. La double façade en large baie vitrée offre une vue sur toute la ville.

Las nuevas dependencias de este centro médico se trataron constructivamente como un casete de cristal, que pretende transportar hacia el exterior la imagen de pureza clínica. La fachada doble acristalada de gran tamaño ofrece vistas sobre la ciudad entera.

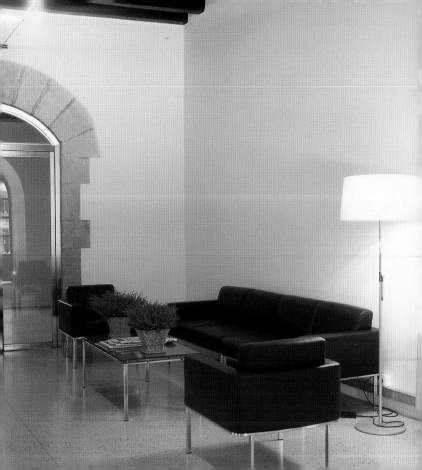

Clínica dental Sangenís

Dental Clinic

BAAS, Jordi Badia, Mercé Sangenís

1999
Carrer de Calaf, 28
Sarrià-Sant Gervasi

www.jordibadia.com

Each of both floors in the orthopaedic dental clinic has its own character. The ground floor with direct access to the street, in which the reception and waiting rooms are found, is designed to be deliberately pleasant and warm. The treatment area in the upper floor presents itself as being clinical and functional.

Beide Geschosse der orthopädischen Zahnklinik haben ihren eigenen Charakter. Das Erdgeschoss mit direktem Zugang zur Straße, in dem sich Rezeption und Wartebereich befinden, ist betont angenehm und warm gestaltet. Der Behandlungsbereich im Obergeschoss präsentiert sich klinisch und funktional.

Chacun des deux étages de clinique dentaire orthopédique son propre caractère. Le rez-de-chaussée avec son accès dire à la rue et sa réception ainsi qu la salle d'attente présentent un conception sciemment agréab et accueillant. L'espace de tra tement à l'étage supérieur rev d'un caractère clinique et fon tionnel.

Ambos pisos de la clínica de ortodoncia poseen un carácter propio. La planta baja con acceso directo a la calle, en la que se encuentra la recepción y la sala de espera, es especialmente agradable y cálida. La zona de tratamiento en la planta alta se presenta, por el contrario, en un estilo clínico y formal.

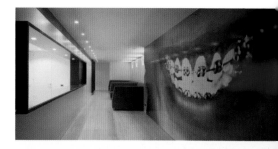

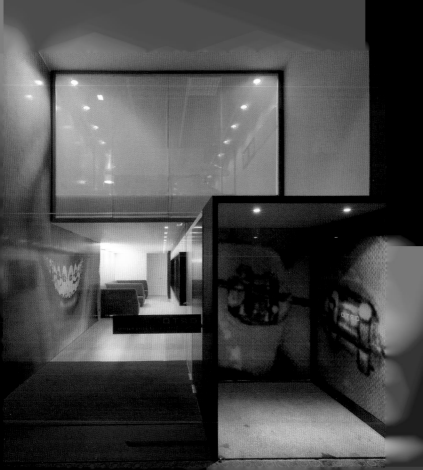

Fitness Center
(Rey Juan Carlos I Hotel)

Carlos Ferrater

1996
Avinguda Diagonal, 661-671
Les Corts

www.ferrater.com

The ring-like arranged fitness area lies in the hills east of the hotel where development sites are not able to support great loads. Therefore, the building is constructed as a sunken concrete structure with a central atrium. The star-shaped walls emerging into the garden area define the individual sports sections in the interior.

Der ringartig angelegte Fitnessbereich liegt in den Hügeln östlich des Hotels, wo der Baugrund nicht sehr tragfähig ist. Deshalb ist das Gebäude als abgesenkter Betonkörper mit zentralem Lichthof konstruiert. Die sternförmig in die Gartenfläche heraustretenden Wände definieren im Inneren die einzelnen Sportbereiche.

L'espace de musculation aménagé en anneau se trouve sur les collines à l'est de l'hôtel où le sol n'est pas très solide. C'est pourquoi, le bâtiment a été construit sous forme d'un corps abaissé en béton à cour centrale de lumière. Les murs saillant comme des étoiles dans l'espace de jardin définissent les différentes sections sportives à l'intérieur.

La zona del gimnasio dispuesto concéntricamente se halla en las colinas en la parte oriental del hotel, donde el terreno no es muy firme. Por esta razón, el edificio se ha construido como bloque de hormigón hundido en el terreno con un patio central de luces. Las paredes que irradian en forma de estrella hacia el jardín delimitan las diferentes zonas de deporte en el interior.

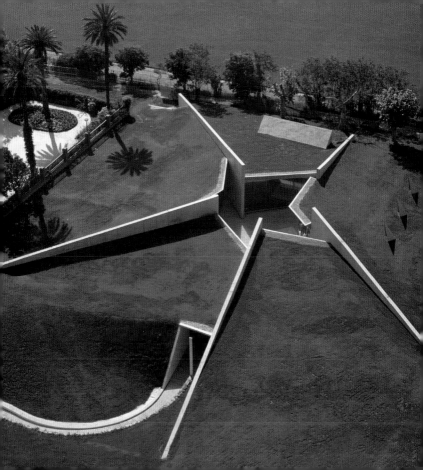

to shop . mall
retail
showrooms

 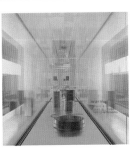

 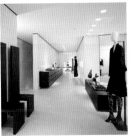

Bisazza Showroom

Fabio Novembre

2001
Carrer de la Fusina, 11
Ciutat Vella

www.bisazza.it
www.fabionovembre.it

For the "tree line" growing out of the floor, the designer used the entire mosaic manufacturer's color palette. One of the sidewalls was realized in shades of green to increase the organic impression. The sky motif was formed based on computer graphics with the corresponding pixel size.

Für die aus dem Boden wachsende „Baumreihe" verwendete der Designer die gesamte Farbpalette des Mosaikherstellers. Um den organischen Eindruck zu verstärken, wurde eine der Seitenwände in verschiedenen Grüntönen ausgeführt. Das Himmelmotiv wurde an Hand einer Computergrafik mit entsprechender Pixelgröße gestaltet.

Pour la « ligne d'arbres » s'élevant du sol, le styliste a utilisé toute la palette de couleurs du fabricant de mosaïques. En vue de renforcer l'impression organique, l'une des parois latérales a été exécutée en différentes nuances de couleur vertes. Le dessin du ciel a été conçu à l'aide d'une graphique d'une trame pixel adéquate réalisée par ordinateur.

Para la "fila de árboles" que asciende desde el suelo, el diseñador ha empleado la paleta completa de colores del fabricante de mosaicos. Para intensificar la impresión orgánica, una de las paredes laterales se ha ejecutado en diferentes tonos de verde. El motivo del cielo ha sido diseñado con ayuda de una gráfica de un programa informático con píxeles correspondientemente grandes.

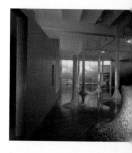

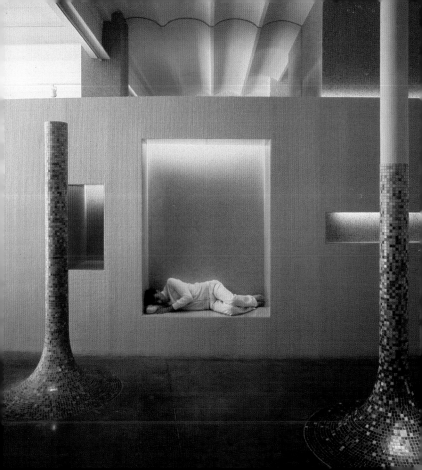

Joan Estrada
Special Events (Fashion)

Joan Estrada, Gs Stands Instalaciones S. L., Raimon Serrahima

2003
Carrer dels Vigatans, 6
Ciutat Vella

www.joanestrada.com

The two-story Special Events showroom designed by Joan Estrada is surrounded by boutiques, restaurants, galleries, and museums. The integrated concept offers a mixture of fashion, jewellery, and accessories from various manufacturers in a minimalist ambience.

Der zweigeschossige, von Joan Estrada gestaltete Special-Events-Showroom ist von Boutiquen, Restaurants, Galerien und Museen umgeben. Das integrierte Konzept bietet eine Mischung aus Mode, Schmuck und Accessoires unterschiedlicher Hersteller in einem minimalistischen Ambiente.

Le salon d'expositions sur deux étages servant aux manifestations spéciales et conçu par Joan Estrada est entouré de boutiques, de restaurants, de galeries et de musées. Le concept intégré offre une mixture de mode, de bijoux et d'accessoires de fabricants divers dans une ambiance minimaliste.

El showroom de dos pisos para acontecimientos especiales diseñado por Joan Estrada está rodeado de boutiques, restaurantes, galerías y museos. El concepto integrado ofrece una mezcla de moda, joyas y accesorios de diversos fabricantes en un ambiente minimalista.

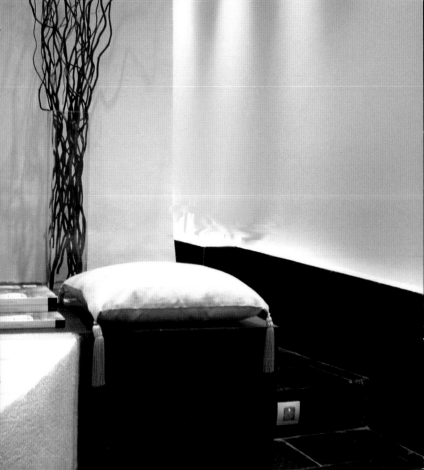

Xocoa
Chocolate Shop

Marta Tobella

2003
Carrer de la Vidrieria, 4
Ciutat Vella

The Xocoa shop is hidden in the Carrer de la Vidrieria. More than two dozen kinds of homemade chocolates as well as filled candies are sold here. In the bright minimalist ambience, the graphically clear designed packages exhibited over a large area come into their own.

Der Xocoa-Laden verbirgt sich in der Carrer de la Vidrieria. Hier werden mehr als zwei Dutzend Sorten hausgemachter Schokolade sowie gefüllte Pralinen verkauft. In dem hellen, minimalistischen Ambiente kommen die großflächig ausgestellten, grafisch klar gestalteten Verpackungen voll zur Geltung.

Le boutique Xocoa se cache dans Carrer de la Vidrieria. Ici, on vend plus de deux douzaines de types de chocolats faits maison ainsi que des chocolats fourrés. Les emballages d'un graphisme et d'une conception clairs et exposés sur une surface importante sont particulièrement bien mis en valeur dans cette ambiance éclairée et minimaliste.

La tienda Xocoa se oculta en la Carrer de la Vidrieria. Aquí se venden más de dos docenas de chocolates y bombones rellenos de diferente tipo de fabricación propia. El ambiente luminoso y minimalista pone óptimamente en escena los paquetes que lucen un diseño gráfico claro y están expuestos ampliamente en la tienda.

Custo Barcelona
Fashion

Frank Lemoine

2002
Carrer de Ferran, 36
Ciutat Vella

www.custo-barcelona.com

With their Custo Barcelona label, the brothers Custido and David Dalmau achieved great popularity within the space of a few years. The boutique in Barcelona is the first of what have become over a dozen shops worldwide in the meantime. The fast growing brand offers clothing, shoes, and accessories for men and women.

Die Brüder Custido und David Dalmau erlangten mit ihrem Label Custo Barcelona binnen weniger Jahre große Popularität. Die Boutique in Barcelona ist die erste von inzwischen über einem Dutzend Shops weltweit. Die schnell expandierende Marke offeriert Bekleidung, Schuhe und Accessoires für Damen und Herren.

Avec leur marque Custo Barcelona, les frères Custido et David Dalmau ont atteint une grande popularité au fil de quelques années seulement. La boutique à Barcelone est le premier parmi plus d'une douzaine de magasins ouverts entre-temps dans le monde entier. La marque en expansion rapide propose des vêtements, des chaussures et des accessoires hommes et femmes.

Con su marca Custo Barcelona, los hermanos Custido y David Dalmau han logrado alcanzar gran popularidad en unos pocos años. La boutique de Barcelona es la primera de más de una docena de tiendas que han abierto entretanto a nivel mundial. Esta marca en rápida expansión ofrece ropa, zapatos y accesorios de señora y caballero.

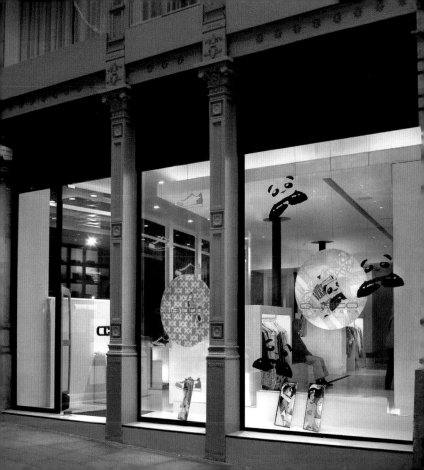

Santa Caterina mercado

Santa Caterina Market

Miralles & Tagliabue Arquitectes Associats
Robert Brufau (SE)

2004
Avinguda de Francesc Cambó
Ciutat Vella

www.mirallestagliabue.com

In the Ciutat Vella district, considered a full-fledged city-in-the-city, the Santa Caterina market plays a key role. In its function as a centre, the market is intended to revitalize urban life after having been redesigned. On the one hand, it should be understood as a simple transit area, on the other as important public space.

In dem Stadtteil Ciutat Vella, der als eine vollständige Stadt in der Stadt gilt, nimmt der Santa Caterina Markt eine Schlüsselstellung ein. In seiner Funktion als Zentrum soll der Markt nach seiner Umgestaltung das urbane Leben revitalisieren. Er ist einerseits als schlichter Durchgangsbereich zu verstehen, andererseits als bedeutender öffentlicher Raum.

Au quartier Ciutat Vella, qui est considéré comme une ville à part entière dans la ville, le marché Santa Caterina occupe une position clé. Après sa restructuration, le marché devra revitaliser la vie urbaine grâce à sa fonction de centre. Sa destination doit être perçue d'une part comme un simple espace de passage et d'autre part comme un espace public important.

En el barrio de Ciutat Vella, considerado como una ciudad completa dentro de la ciudad, el mercado de Santa Caterina posee una función clave. Como núcleo del barrio, el mercado tiene la función de revitalizar la vida urbana tras su remodelación. Por una parte, se considera como una simple zona de paso y, por otra, como un espacio público de importancia.

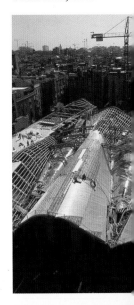

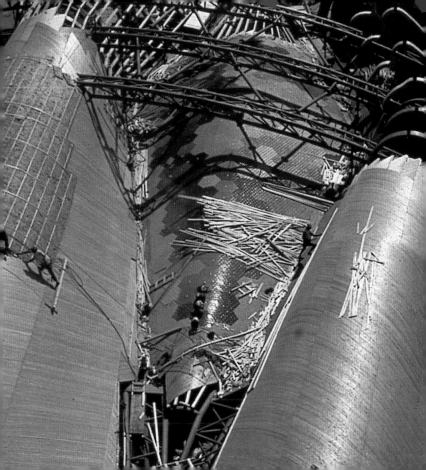

Joyería Majoral

CCT Arquitectos
Conrado Carrasco, Carlos Tejada (SE)

2002
Carrer del Consell de Cent, 308
Eixample

www.majoral.com
www.cctarquitectos.com

The entrance to the jewellery shop is somewhat recessed into the salesroom. However, the main showcase stretches into the open through the glassed-in facade. This is intended to allow one to be able to enter naturally. Furniture is placed along the walls, which is used as exhibition area.

Der Eingang des Juweliergeschäftes ist etwas in den Verkaufsraum zurückversetzt. Der zentrale Schaukasten hingegen erstreckt sich durch die verglaste Fassade hindurch bis ins Freie. Dadurch soll ein natürlicheres Eintreten ermöglicht werden. An den Wänden befinden sich Möbel, die als Ausstellungsfläche dienen.

L'entrée de la bijouterie est légèrement en retrait, vers l'espace de vente. La vitrine centrale, en revanche, s'étend jusqu'à l'air libre, en passant par la façade vitrée. Ceci doit permettre aux clients d'y pénétrer naturellement. Sur les urs se trouvent des meubles servant d'espaces d'exposition.

La entrada a la joyería penetra algo en la sala de venta. La vitrina central, por el contrario, se extiende hasta el espacio exterior a través de la fachada acristalada, lo que permite un acceso más natural a la joyería. De las paredes cuelgan muebles que sirven de superficie de exhibición.

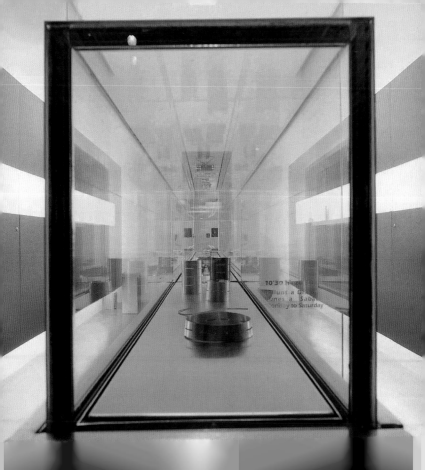

248 Kids' Stuff

José Luís Portillo, Merino-Portillo

2003
Carrer del Rosélló, 248
Eixample

The idea for the children's shop is a clear graphic concept with playful contrasts in color, light, and scale. Large numbers over the display allocate the clothing to the age groups like a tape measure. The children can actively contribute to the design using the blackboard.

Die Idee des Kinderladens ist ein klares grafisches Konzept mit spielerischen Kontrasten in Farbe, Licht und Maßstab. Große Zahlen über der Auslage ordnen die Kleidung wie ein Maßband den Altersgruppen zu. An der Maltafel können die Kinder aktiv mitgestalten.

L'idée du magasin pour enfants est basée sur un concept graphique clair aux contrastes ludiques au niveau des couleurs, de la lumière et de l'échelle. Les grands chiffres au-dessus des marchandises exposés classent les vêtements en fonction des groupes d'âge, à l'instar d'un ruban gradué. Le tableau de dessin permet aux enfants de contribuer activement à la conception.

La idea de esta tienda de moda infantil es un concepto gráfico de líneas claras con juguetones contrastes de color, luz y dimensiones. Números de gran tamaño aplicados sobre el mostrador clasifican la ropa como una cinta métrica según las diferentes edades infantiles. En la pizarra, los niños pueden imprimir a la tienda su propia nota decorativa.

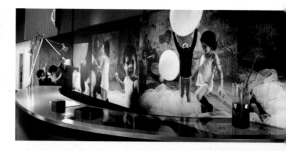

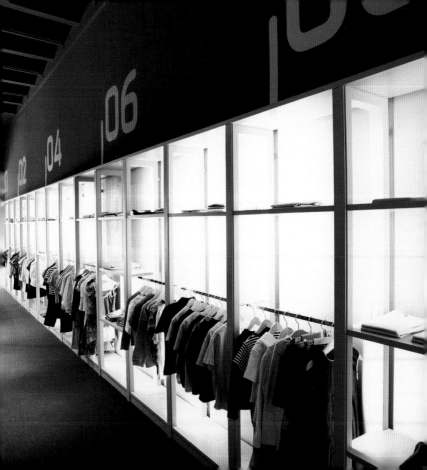

Mercado de la Barceloneta

Josep Miàs Arquitecto
Europrincipia Ingenieros (SE)

2005
Plaça de la Barceloneta
Cuitat Vella

www.josepmias.com

In order to preserve the appearance of the market hall despite new fittings, the architects preserved the supporting structure. They developed the new space in exactly this structure, which they simply expanded. The attached constructional components are made out of the same metal profiles as the old supporting structure.

Um das Erscheinungsbild der alten Markthalle trotz neuer Einbauten zu wahren, haben die Architekten das Tragwerk erhalten. Den neuen Raum entwickelten sie in eben dieser Struktur, die sie einfach erweiterten. Die hinzugefügten, konstruktiven Bauteile bestehen aus den gleichen Metallprofilen wie das alte Tragwerk.

En vue de conserver l'aspect le caractère de la vieille halle marché malgré les nouveaux él ments intégrés, les architect ont maintenu l'ossature porteus Ils ont développé le nouvel esp ce précisément dans cette stru ture qu'ils ont simplement éla gie. Les éléments rajoutés à construction sont constitués de mêmes profils métalliques q l'ancienne ossature porteuse.

Para no modificar el aspecto exterior del antiguo mercado a pesar de los nuevos anexos, los arquitectos han conservado la estructura portante. El nuevo recinto lo han diseñado precisamente con esta estructura, ampliándola simplemente. Los componentes constructivos añadidos están compuestos por los mismos perfiles metálicos que la antigua estructura portante.

Giorgio Armani

Claudio Silvestrin

2003
Avinguda Diagonal, 550
Sarrià-Sant Gervasi

www.claudiosilvestrin.com

While designing the new Giorgio Armani boutique, Claudio Silvestrin attached great importance to timeless, natural materiality. To that effect, the surfaces of the walls and floor are made of French limestone; the furniture is produced from ebony.

Claudio Silvestrin legte bei der Gestaltung der neuen Giorgio-Armani-Boutique großen Wert auf zeitlose, natürliche Materialität. So bestehen die Oberflächen der Wände und Böden aus französischem Kalkstein, die Möblierung ist aus Ebenholz gefertigt.

En concevant la nouvelle boutique Giorgio Armani, Claudio Silvestrin a mis l'accent notamment sur une matérialité naturelle et intemporelle. Ainsi, les surfaces des murs et des sols sont constituées de grés calcaire français, l'ameublement est en bois ébène.

A la hora de decorar la nueva boutique de Giorgio Armani, Claudio Silvestrin le dio especial atención a los materiales naturales intemporales. Así, por ejemplo, las superficies de paredes y suelos son de piedra calcárea francesa, mientras que el mobiliario es de madera de ébano.

176

Nuevo mercado de las flores

New Flower Market

WMA Willy Müller, Fred Guillaud

2005
Zona Franca

www.willy-muller.com

The flower market is divided into two event areas that communicate with each other through a large air space. Cut flowers are found in the lower area; upstairs the market for potted plants and accessories. The building envelope is conceived as a colorful dress.

Der Blumenmarkt ist in zwei Aktionsbereiche unterteilt, die durch einen großen Luftraum miteinander kommunizieren. Im unteren Bereich befinden sich die Schnittblumen, oben der Markt für Topfpflanzen und Zubehör. Die Gebäudehülle ist als farbenfrohes Kleid konzipiert.

Le marché aux fleurs est divis� en deux sections d'activités q� communiquent via un gran� espace d'air. À l'étage inférie� se trouvent les fleurs à la coup� à l'étage supérieur le marché au� plantes en pot et les accesso� res. Le mur rideau du bâtime� a été conçu comme une rob� gaie et colorée.

El mercado de las flores está dividido en dos zonas de actividades, que están comunicadas entre sí a través de un gran espacio vacío. En la parte inferior se encuentran las flores cortadas, arriba el mercado para plantas en macetas y accesorios. La carcasa del edificio se ha concebido como un vestido multicolor.

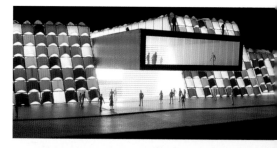

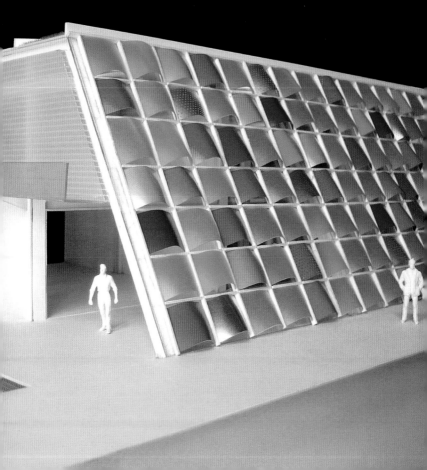

Index Architects / Designers

Index Architects / Designers

Index Structural Engineers

Index Districts

Index Districts

Index Districts

Photo Credits

Other photographs courtesy

Abalos & Herreros Archive (86), Archikubik (14, 42, 72, 73), Arriola, Andreu (90), Ateliers Jean Nouvel, Artefactory (6, 7, 34, 35), Bach, Jaume (18), Ferrater, Carlos (20, 88), Claudio Silvestrin Archive (176, 177), Comerç24 Archive (126,127), Custo Archive (166, 167), Despacho Josep Miàs (174, 175), Estudio Joan Pascual Argenté (30, 54), Fargas arquitectes Archive (40, 41), Fiol, Carmen (90), Futur-2 Archive (134, 135), Herzog & de Meuron (84), MBM Arquitectes (22, 68), Miralles & Tagliabue Archive (2, 32, 33, 80, 81, 116, 117, 168, 169), Mora, Gabriel (18), Perrault Projets (104, 105), Bofill, Ricardo (48), Roldan + Berengué (36), WMA Willy Müller (28, 178,179)

Imprint

teNeues Book Division
Kaistraße 18
40221 Düsseldorf, Germany
Phone: 0049-(0)211-99 45 97-0
Fax: 0049-(0)211-99 45 97-40
E-mail: books@teneues.de

Press department: arehn@teneues.de
Phone: 0049-(0)2152-916-202

www.teneues.com
ISBN 3-8238-4574-8

teNeues Publishing Company
16 West 22nd Street
New York, N.Y. 10010, USA
Phone: 001-212-627-9090
Fax: 001-212-627-9511

teNeues Publishing UK Ltd.
P.O. Box 402
West Byfleet
KT14 7ZF, UK
Phone: 0044-1932-403 509
Fax: 0044-1932-403 514

teNeues France S.A.R.L.
4, rue de Valence
75005 Paris, France
Phone: 0033-1-55 76 62 05
Fax: 0033-1-55 76 64 19

Bibliographic information published by Die Deutsche Bibliothek
Die Deutsche Bibliothek lists this publication in the Deutsche Nationalbibliografie;
detailed bibliographic data is available in the Internet at http://dnb.ddb.de

Editorial Project: fusion-publishing GmbH www.fusion-publishing.com
Edited by Sabina Marreiros; written by Jürgen Forster
Concept by Martin Nicholas Kunz
Layout & Pre-press: Thomas Hausberg
Imaging: Florian Höch
Maps: go4media. – Verlagsbüro, Stuttgart

Translation: ADE-Team
English: Robert Chengab
French: Birgit Allain
Spanish: Margarita Celdràn-Kuhl

Printed in Italy

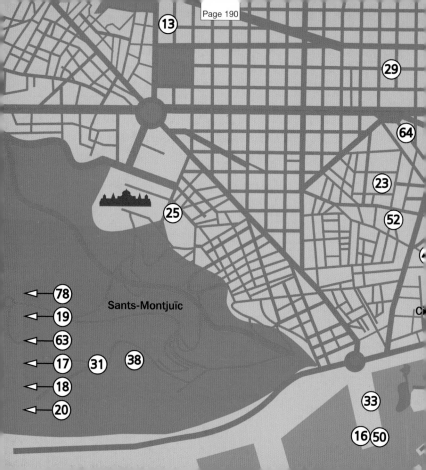

(13)

(29)

(64)

(23)

(52)

(25)

(78)

Sants-Montjuïc

(19)

(63)

(17) (31) (38)

(18)

(20)

C

(33)

(16)(50)